Animated Realism

Animated Realism

A Behind The Scenes Look at
the Animated Documentary Genre

Judith Kriger

Routledge
Taylor & Francis Group
New York London

First published 2012 by Focal Press

Published 2019 by Routledge
2 Park Square, Milton Park, Abingdon, Oxon OX14 4RN
52 Vanderbilt Avenue, New York, NY 10017

Routledge is an imprint of the Taylor & Francis Group, an informa business

Notices
Practitioners and researchers must always rely on their own experience and knowledge in evaluating and using any information, methods, compounds, or experiments described herein. In using such information or methods they should be mindful of their own safety and the safety of others, including parties for whom they have a professional responsibility.

Product or corporate names may be trademarks or registered trademarks, and are used only for identification and explanation without intent to infringe.

Library of Congress Cataloging-in-Publication Data
Application submitted

British Library Cataloguing-in-Publication Data
A catalogue record for this book is available from the British Library.

ISBN 13: 978-0-240-81439-1 (pbk)

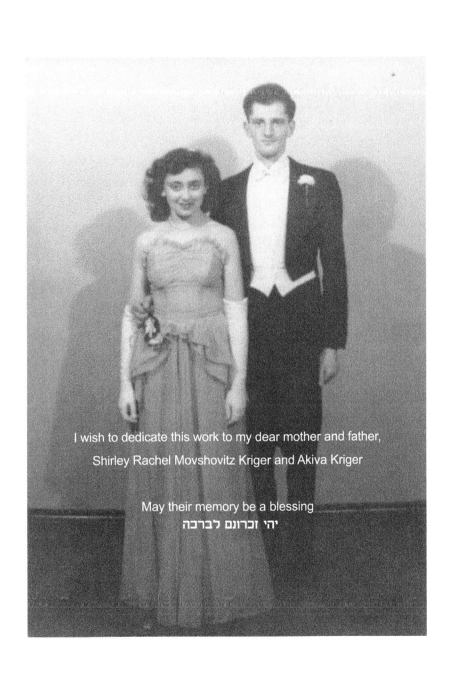

I wish to dedicate this work to my dear mother and father,

Shirley Rachel Movshovitz Kriger and Akiva Kriger

May their memory be a blessing
יהי זכרונם לברכה

Contents

Acknowledgements

To those who have assisted me in the development of this book, I hope to acknowledge here the gratitude I feel:

To the *Animated Realism* team at Focal Press, and especially to my editor, Katy Spencer, thank you for saying "Yes!" and believing in me. To Tom White, my technical editor, thank you for your insightful comments, suggestions, and honest feedback.

Thank you to my colleagues—Gil Bettman, for sitting me down and encouraging me to develop and pitch the book idea, and Jeff Swimmer, for your infectious enthusiasm for documentary filmmaking.

Thank you to Michael Grusd, Naomi Hirsch, Diane Saltzberg, and especially to Dr. Allison Weiss for your encouragement. I would also like to thank Linda Charyk Rosenfeld and David Kriger for reviewing the manuscript and offering supportive feedback.

Thanks to the directors who inspired me to write this book and who gave generously of their time, experience, and works of art: John Canemaker, Paul Fierlinger, Yoni Goodman, Chris Landreth, Bob Sabiston, Marie-Josée Saint-Pierre, and Dennis Tupicoff. It's been an honor and a pleasure getting to know each of you.

And finally, I'd like to give a special thanks to my students in the Digital Arts Department at the Dodge College of Film and Media Arts at Chapman University for asking good questions and reminding me that learning is a lifelong journey.

Contributors

John Canemaker - An Academy Award-winning independent animator, animation historian, teacher, and author, John Canemaker has screened his work to great acclaim at film festivals, museums, and universities around the world. Canemaker is a full professor and director of the Animation Program at New York University Tisch School of the Arts. In 2009 he received the NYU Distinguished Teaching Award for "exceptional teaching, inside and outside the classroom." Canemaker won a 2005 Oscar and an Emmy Award for his 28-minute animated short The Moon and the Son: An Imagined Conversation. A distinguished author of 10 titles, his latest book is Two Guys Named Joe: Disney's Master Animation Storytellers Joe Grant and Joe Ranft, published by Disney Editions.

Paul Fierlinger - Paul formed AR&T Associates, Inc., his own animation house, in 1971, initially to produce animated segments for ABC's Harry Reasoner Specials and PBS's Sesame Street, including Sesame Street's popular Teeny Little Super Guy series, which runs to this day. Since 1971, AR&T has produced over 700 films, several hundred of which are television commercials. Many of these films have received considerable recognition, including an Academy Award nomination for It's so Nice to Have a Wolf Around the House. Other awards include Cine Golden Eagles, and Best in Category Awards at festivals in New York, Chicago, Los Angeles, Annecy, Ottawa, Zagreb, Milan, Melbourne, Prague, London, and many other cities and countries - well over a hundred major film festival awards all together.

Yoni Goodman - Born in 1976, Yoni Goodman began his career as an illustrator and designer for Maariv and Haaretz, two major Israeli newspapers. While studying in the Department of Visual Communication at the Bezalel Academy of Art and Design in Jerusalem, Goodman fell in love with animation and hasn't stopped making it since. Yoni was the Director of Animation for Waltz with Bashir (2008) and developed the Adobe Flash cut-out animation technique needed to create this feature.

Chris Landreth received an MS degree in theoretical and applied mechanics from the University of Illinois in 1986. For three subsequent years, he worked in experimental research in fluid mechanics at the University of Illinois with his advisor, Ronald J. Adrian. Landreth was responsible for developing a fluid measurement technique known as Particle Image Velocimetry (PIV), which has since become a fundamental way of measuring fluid flow. He received two patents for his work on PIV during his time at the University of Illinois. In 1989, Landreth studied computer animation under Donna Cox, at the National Center for Supercomputing Applications (NCSA). It was at this point that he created his first short film, The Listener (1991), a film that won him

notoriety by being shown on MTV's Liquid Television the following year. In 1994, Landreth joined Alias Inc. (now Autodesk Inc.) as an in-house artist. It was his job to define and test animation software before it was released to the public. His work was one of the driving forces in developing Maya 1.0, in 1998. Today Maya is the most widely used animation and VFX software package in production, and Alias subsequently was given an Academy Award for this in 2003.

Bob Sabiston - Bob Sabiston and his company, Flat Black Films, have been making innovative animation since 1987. His student films from the MIT Media Lab, Grinning Evil Death and God's Little Monkey, were some of the first films to combine 2D and 3D computer animation. Sabiston's own films, including Roadhead, Snack and Drink, and Grasshopper, have been influential in the burgeoning field of animated documentary.

Marie-Josée Saint-Pierre - Born in Murdochville, Quebec, Marie-Josée Saint-Pierre is a French Canadian filmmaker based in Montreal, Canada. Saint-Pierre obtained a BFA Honors in film animation and an MFA in film production from the Mel Hoppenheim School of Cinema at Concordia University. The award-winning director and film animator has directed several short animated and documentary films, including Post-Partum, an exploration of abandonment and postpartum depression; Passages, an autobiographical story about the birth of the filmmaker's first child; The Sapporo Project, a unique animated glimpse into the world of acclaimed Japanese calligrapher Gazanbou Higuchi; and McLaren's Negatives. Marie-Josée Saint-Pierre founded MJSTP Films Inc., an animation and documentary production company, in 2004. Her film work has been screened at over 150 prestigious festivals around the world while receiving many awards.

Dennis Tupicoff - Dennis Tupicoff was born in 1951 and graduated from Queensland University in 1970, later completing the Swinburne Film and TV School animation course in 1977. After working as a writer/ director/producer of his own films as well as TV commercials and other commercial and sponsored work, he was appointed Lecturer in Animation at the Victoria College of the Arts School of Television (1992—1994). Since then he has continued making independent films as writer, director, producer, and often designer/animator.

Introduction

One of the most magical and memorable experiences of my professional animation career was having the honor of meeting Steven Spielberg. I was living in the San Francisco Bay Area and working as an animator on feature animation, visual effects, and commercials. DreamWorks had recently purchased the studio I was working for, and Spielberg flew up for the day from Los Angeles to meet his new staff in Palo Alto. Although there were hundreds of us, he patiently took the time to meet us individually. In addition to briefly introducing myself to Steven Spielberg and shaking his hand, what I remember most about that remarkable day is what he said to us about animation. He talked about how in directing live-action films, often the best part of an actor's performance are the "mistakes" that are made. For example, sometimes during the middle of a take, the actor will sneeze or trip over something, causing an otherwise unscripted motion in his or her performance that adds to the believability of the scene. Spielberg went on to talk about how he wished animated films had more "mistakes," as they're often too perfect, which takes away from the enjoyment of the film. This is the memory of him that has vividly remained with me, all these years.

The term *animation* means many things to many people. Animated films can entertain or educate, or they can be a form of artistic self-expression. Whether created in the form of a personal, auteur-style short, a big-budget Hollywood blockbuster, or an educational app for the constantly changing array of handheld gizmos, in today's media-driven world animated content is more popular and powerful than ever.

Documentary films are captivating because of their strong and engaging factual stories. Whether in the form of journalism or self-expression, nonfiction films can be both educational and entertaining. Does shooting live footage of a particular subject make the film any more truthful than drawing the subject matter? Animation is not usually associated with documentary filmmaking, yet the directors profiled in *Animated Realism* are exemplars of this hybrid form of expression by telling unforgettable stories using iconic imagery. This book was written because it's important for directors and students of both the animated and documentary forms to understand how these forms of storytelling can be combined together in uniquely powerful and imaginative ways.

As Pulitzer-Prize—winning author Willa Cather wrote in her novel *O Pioneers!*, "There are only two or three human stories, and they go on repeating themselves as fiercely as if they had never happened before." We learn about ourselves and others by connecting through storytelling. Mythologist Joseph Campbell identified universal patterns that are used quite extensively in

storytelling, including stories told through the language of film. These patterns of archetypal characters appear in movies like the *Star Wars* series and *The Lord of the Rings* trilogy and help to explain the almost religious devotion that audiences worldwide demonstrate for these films.

Although it may be true that there are only two or three human stories, the ways in which these stories are created and circulated are constantly being reinvented. Distributing one's films outside of the studio system has never been easier or cheaper. Gone are the days of being required to shoot on film, wait for the lab to process the negative and print, rent a flatbed for editing at a per-hour rate, and only be able to view the finished film with a projector and screen. Today's independent animation, visual-effects-driven, and live-action films are made with accessible, high-end digital software and smaller, more portable than ever digital cameras, edited on laptops, and viewed on a wide-ranging, ever-evolving variety of gadgets. The ability to self-distribute and promote one's own artistic work has dramatically benefited from the Internet and ever-changing social media outlets. Web 2.0 allows creative artists to get their work "out there" and begin marketing their talent and demo reels to a worldwide audience within minutes, rather than weeks or years. Word-of-mouth spreads instantaneously and globally in the digital age.

But the ability to harness technology isn't the only characteristic necessary to create engaging stories with content. Telling factual stories in creative ways challenges the movie-going audience to listen and watch more closely. The fusion of nonfiction filmmaking with animation has greatly enhanced the world of documentary filmmaking and challenges us to confront our expectations and preconceived definitions about what both documentary and animated filmmaking are. Mixing in a medium that is typically used to tell fictional stories with documentaries causes the negative space, the imperfect space "between" the two genres to be all the more powerful. Not only visually stimulating, animation gives the genre of animated documentary a fresh, dynamic approach to storytelling. Directors of animated documentaries are breaking new ground and attracting audiences to their work because they are telling their stories in inventive ways and pushing the medium forward.

Though small amounts of animation have appeared before in a variety of documentary films, *Animated Realism* explores the work of pioneering directors who have thoughtfully crafted their entire nonfiction films in the animated form. In the 2008 Oscar-nominated *Waltz with Bashir*, animation director Yoni Goodman pushes readily available turnkey software in new ways and creates extraordinary, iconic imagery of repressed wartime memories. Bob Sabiston's pioneering software and influential look development have brought rotoscoping into the 21st century and produced the memorable animation styles of *Waking Life* and *A Scanner Darkly*. *The Moon and the Son: An Imagined Conversation* is director John Canemaker's 2005

Oscar-winning personal documentary, which uses the intimacy of hand-drawn animation to ask difficult and often painful questions of his father. Animator and director Marie-Josée Saint-Pierre's films courageously bring women's issues to the fore and use the animated documentary form to creatively portray Canadian filmmaking luminaries Norman McLaren and Claude Jutra. Dennis Tupicoff's background in animation and his wry sense of humor inform his award-winning animated documentary style. In *Ryan*, director Chris Landreth uses CG animation to create his 2004 Oscar-winning animated documentary film portrayal of well-known animator Ryan Larkin. Director and animator Paul Fierlinger has a renowned career in the animated documentary genre; he and his wife Sandra Fierlinger direct, animate, and distribute their beautifully hand-drawn feature-length films. The work of these directors shows the successful integration of animation with documentary and inspires artists and filmmakers alike to create original and compelling work.

Will the film be liked? Does it have the potential of reaching a broad audience? There will always be unknowns that the director must learn to live with, accept, and ultimately incorporate into the creative process. The contrast between the use of imperfect, shaky lines or non-"traditional" 3D computer graphics in animated docs and their intensely personal stories is what helps make the animated documentary so fascinating and compelling to watch. The joyful, visual imperfection in this mashed up filmmaking hybrid is precisely what reminds us that these are very real, very human stories. Spielberg, in his desire for imperfection in animation, had it right after all.

I find it interesting that my final manuscript is due on what would have been my father's 87th birthday. He passed away on March 5, 2011, after a hard-fought battle with brain cancer—before the completion of this book, though knowing it would be dedicated to him. My father was a gentle soul, a thoughtful and very intelligent man who worked as a civil engineer and had a keen understanding of math and science. But he also loved the arts. I have very fond childhood memories of sitting down to watch *Bugs Bunny* cartoons with my father, my late sister Diane, and my brother David. We all enjoyed these times and laughed together, and I think this experience, to a certain degree, influenced my desire to become an animator. My father paid for my first drawing lessons at the Ottawa School of Art, my first real training as an artist when I was a teenager, and later as a college student, he encouraged me to get summer jobs with Atkinson Film Arts, an animation studio that created Christmas specials and half-hour TV shows. He was thrilled when I was accepted into RISD, the Rhode Island School of Design, one of the top art and design colleges in the United States.

My father had an amazing knowledge of classical music and composers, and he met my mother in a classical music club while they were going to university. Though she passed away during my childhood, I have very strong memories of her and my uncle taking me to the movie theater to see

The Jungle Book. I learned early in my life that my mother appreciated the arts; she enjoyed playing Masterpiece, a Monopoly-type of board game for artists that entailed buying and selling famous works of art. My mother collected framed Renoir prints from the Metropolitan Museum of Art, and both she and my father appreciated a particular Renoir still life called *Onions*, which is still on display at the Clark Art Institute in Williamstown, MA.

Long before cloud computing and iPods, working with computer technology entailed having to use computer keypunch cards, something my mother was just beginning to learn before she died. I now realize that her interest in art and technology has been carried forward in me; my love of art and animation and obsession with computer software and hardware are passions that have guided and inspired me for decades. I am very much my mother's daughter.

For my dear parents, Shirley and Akiva Kriger, who would have been so proud.
May their memory be a blessing.
Los Angeles, CA
July 29, 2011

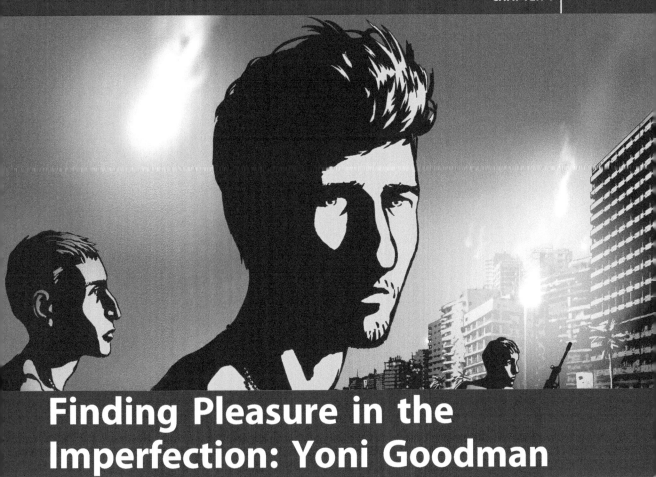

Finding Pleasure in the Imperfection: Yoni Goodman

There's No School Like the Old School

Documentary films date back many decades. John Grierson, a Scottish documentary filmmaker born in 1898 and considered the father of documentary filmmaking, defined documentary as "the creative treatment of actuality." While studying in the United States, Grierson concentrated his research on the psychology of propaganda, focusing on how public opinion is formed and influenced by mass media, film, and the press. What a field day Grierson would have had today, with the explosion of reality TV shows, social media networking, the Internet, and 24-hour cable news networks.

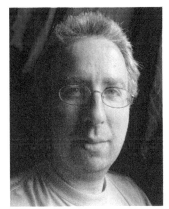

FIG 1.1 Yoni Goodman.

Grierson was effectual in developing documentary cinema in both Britain and Canada but clearly didn't hold the Hollywood entertainment industry in the highest regard. In his 1932 essay, "First Principles of Documentary," Grierson felt that Hollywood movies didn't care to show the real world and instead focused on fictional, "artificial" stories. How would he have felt about using animation to tell nonfiction stories? Would the use of digital or hand-drawn "artificial backgrounds" take away from the realism Grierson sought, or would current trends in fusing animation with documentary work believably as "creative treatments of actuality"?

Comic strip artist and animator Winsor McCay's *The Sinking of the Lusitania,* copyrighted in 1918, was an animated film depicting the real-life torpedoing of the English Cunard liner Lusitania by a German submarine off the coast of Ireland and can be considered a precursor to today's animated documentaries. Max Fleischer began working in animation in 1915 and also got his start as a newspaper cartoonist. Together with his brother Dave, they patented the process known as Rotoscope in 1917. Their invention allowed the artist to draw frame-by-frame over live-action footage and is very much responsible for the look development of many of today's animated documentaries. Fleischer Studios created such memorable characters as Betty Boop and the star of the *Out of the Inkwell* series, KoKo the Clown.

The inventive influences of McCay and the Fleischer brothers have been carried forward to modern times in the pioneering feature documentary "Waltz With Bashir". Animation Director Yoni Goodman used a 2D, hand-drawn look to help tell Director Ari Folman's unforgettable story.

Biography

Born in 1976, Yoni Goodman began his career as an illustrator and designer for *Maariv* and *Haaretz*, two major Israeli newspapers. While studying in the Department of Visual Communication at the Bezalel Academy of Art and Design in Jerusalem, Goodman fell in love with animation and hasn't stopped making it since.

After graduating in 2002, he worked as a freelance animator and illustrator for numerous TV shows and commercials. In 2004, Goodman worked as Director of Animation for Ari Folman's documentary series, *The Material That Love Is Made Of*, creating three five-minute animated shorts that were used in the series. Goodman's successful connection with Ari Folman led to their next collaboration, *Waltz with Bashir* (2008). Goodman was Director of Animation and developed the Adobe Flash cut-out animation technique needed to create this feature.

Goodman has taught animation in the Bezalel Academy of Arts and Design and lives in Israel with his wife Gaya and their children Anat, Itamar, and Noa. He claims to suffer from a mild addiction to chocolate and coffee, which he says he can quit anytime he wants.

FIG 1.2
Printed with Permission, ©Bridgit Folman Films Gang LTD. 2009.

Interview

Judith Kriger: *How did you first get involved with animation?*

Yoni Goodman: After my military service, I started working at a newspaper. Afterwards, I went to an art school called Bezalel when I heard they had an animation course there.

JK: *Can you describe what the program is like at Bezalel?*

YG: When I was there, I studied in visual communications, which meant I was involved with graphic design, illustration. At that time [around 2000], animation was more of a specialized course, not a major. Nowadays, animation at Bezalel is a very developed, structured department, and has won a few prizes. Up until two years ago, I taught Flash, animation, and mentored some of the senior projects there. I had to give up teaching, though, because it became a bit too much with all my other [commercial and feature] jobs.

JK: *Who or what influences you?*

YG: A lot of things. All sorts of animation. Early Disney work, Milt Kahl's work, stuff like that. For the next feature, we're researching the Fleischer Studios' work. This is probably my favorite animation studio. The art in our next feature is going to be loosely based on the Fleisher cartoons—the "old school" style. They did some amazing stuff in their early cartoons.

JK: *What attracts you to their work?*

YG: It's interesting because at that point in time, Disney and Fleischer Studios were pretty much equal. Disney, of course, made *Steamboat Willie*, and then they went on to make *Snow White*, and Fleischer Studios eventually collapsed. They made some really wild, crazy animation. It's interesting—the period when those two studios were at their highest—I think about what animation might have looked like today if the Fleischers had won the "fight," so to speak. Disney always went for the very emotional cartoons, and the Fleischer cartoons were really hard-core, crazy.

JK: *That is an interesting thought; think about how different Pixar would have been today if that had happened.*

YG: That's the ironic thing about Pixar, actually, because they are "dropouts" from DIsney. Disney said, "we don't want you; you're too wild and crazy," and now John Lasseter controls all the creative aspects of Disney. I'm sure he's laughing about it constantly, because you know—they kicked him out. He showed them!

JK: *He sure has!*

YG: I'm not overly fond of the later Disney work; I like their earlier stuff. Maybe it's because I'm now trying to get back to the core of animation, get back to where it all began. I'm really studying the early days of animation; all the Winsor McCay work. There's some amazing stuff there. That's the difference—in early animation, you can see that the animators were exploring. For example, it's the difference between *The Jungle Book* and *The Jungle Book 2. Jungle Book*, for me, is one of the top five animated films ever. When you look at it closely, you see tons of "mistakes"—not truly

mistakes, but what I mean is that you can see that some of the characters are not drawn perfectly anatomically correct, and you can see the roughness of the line. You can also sometimes see the brushstrokes in the backgrounds, and it's real magic. In *Jungle Book 2*, everything is so perfect . . . and so boring! I'm not saying that to criticize Disney animators, because they're amazing craftsmen—it's just that it's a little too "perfect." I find pleasure in the imperfection, and that's exactly what I see in the early cartoons.

JK: *Yes, it's similar to watching, for example, Aardman Studios' work and noticing fingerprints in the clay. This is one of the things that attracted to me to Waltz with Bashir: the story is very personal and so intense, and you've made it look like it's hand-drawn, and you see the imperfection in the line. You can therefore see the human being behind the "camera"—this, to me, is one of the reasons why it works so well.*

YG: I'm very pleased with the way the animation turned out. It was like a solution to a problem. It is actually very technical, because we used Flash to make it look like cut-out animation. Doing the animation on *Bashir* was like solving a riddle.

JK: *What are some of the other movies in your Top 5 list?*

YG: One of my biggest influences was Joanna Quinn's *Britannia*. It's amazing—I saw it as a kid—it was one of those things when you say, I want to do that for a living! It has the look of rough pencil, and everything is very alive. Another movie that really influenced me is *When The Wind Blows*, made in the 1980s. The story describes an elderly couple who experience a nuclear holocaust—but they don't get the blast, they get the radiation. For 90 minutes, you watch them dying in front of you. This movie really showed me the power of animation. I saw this movie as a kid, and I think it actually affected me more than I knew at the time. You can see drawn human figures and really relate to them; you can really feel them. It's a sad, melancholic movie, but it also has its high points and definitely is worth seeing.

Also on my list . . . *The Incredibles*. I'm a big Brad Bird fan. I like all the Pixar movies—except *Cars*. This was also a big lesson for us on *Bashir*: it's not about the animation; it's about arriving at the story. It's about making things fit for the story and not making the story fit for the roller-coaster ride. This is one of the main problems with 90% of the CG movies. In almost every CG movie they have these crazy camera movements and everything moves. Pixar's movies, on the other hand, hardly ever do that. They focus on the story, and if there's a roller-coaster scene, it serves the story. In general, CG bores me a bit.

JK: *What about it bores you?*

YG: Of all the forms of animation, I think CG is the toughest—except, maybe, clay animation. Clay animation is hard because it's very physical and you can make tons of mistakes. You move your elbow the wrong way and your whole

day is ruined. But clay has the magic of being of an organic nature, and that goes a long way. But CG is like a blank page, and you have to fill it with everything. Animation is all about fooling the eye—making the eye see what's not really there. Nothing about it is real, but you make the eye think it's real. In traditional animation it's really easy, because the eye is really easily fooled. As an extreme example, *South Park*, which is really rough, works—the eye is fooled because it accepts the "rules" of that world. It takes a few seconds, but then you accept it for its visual simplicity and focus on the story. They intentionally make it look simple and mechanical so that the story will come through.

On the other extreme . . . is CG. You model something in CG and it has a mass; the eye picks up the mass. The more you give the eye, the more it demands. This is why I think realistic CG animation will never work. I see all these technological advances, but when you try to get close to reality, that's when the eye starts to pick up the small details, and it ruins the illusion. In CG productions, in order to achieve a level of believability, you need to have the budget of a major studio like Pixar, Blue Sky, DreamWorks. They are able to get you interested, and you don't look at the characters just as modeled polygons. The reason is they have tons of money and tons of people working on these; they have budgets of 100 million dollars per feature. I think only about 10% of the potential of CG has been properly explored. Every studio, every animation student wants to be the next Pixar. I recently had an interview with a few guys in Madrid who said: "We're going to be the next Pixar!" How? You have a budget of 2 million dollars—how will you beat Pixar?

FIG 1.3
Printed with Permission, ©Bridgit Folman Films Gang LTD. 2009.

Do you think they spend it all on coffee and cookies? <laughs> And these are some of the issues we discussed on *Bashir*—and this is why we chose a completely different look. If we had tried to make something to compete with Disney, that would have been the worst mistake ever. We decided to make something so completely different that no one would ever think to compare us to them.

JK: *Do you think it's possible to make animated documentaries with CG?*

YG: Of course. You know . . . there was a big discussion about whether or not *Bashir* was a documentary. At one point, Ari was giving numerous interviews each day, and they kept asking him, "Is it a documentary?" By the end he got fed up and he said, "You know what? It's whatever you want it to be." <laughs> CG can be anything. It's a tool; it's nothing more than a tool. I don't mean to come off like I hate CG—I don't hate CG, I just hate what's being done with it because everyone is trying to do the same thing. I don't think traditional or clay animation has been fully explored yet, either. With clay animation—you have Aardman as one example and Jan Švankmajer as another—these are crazy examples of the extremes in styles of clay animation. CG can go much, much further. Animation is not just a kids' medium; it's an art field.

And as an art field, it can deal with anything, any topic. This is something that really pissed off Winsor McCay. He saw animation as an art form; he was an artist and was frustrated that his work became known as something only for kids. Kids are a great audience, of course . . . but animation can be anything, I think.

The Art of Cut-Out Animation

There are numerous techniques and styles used in creating animation, including a method known as cut-out animation. This process entails cutting out pieces of flat paper, fabric, or photographs and arranging them on top of a background, then moving the pieces in subtle amounts while the camera takes two pictures (usually) of each independent movement. Lotte Reiniger's graceful work *The Adventures of Prince Achmed* is one of the world's first feature-length animated films and was created with silhouetted cut-out paper shapes in 1926. More recently, the Nickleodeon series *Blue's Clues* simulated this technique digitally, and though Comedy Central's *South Park* is produced with high-end CG software, it is made to look as if it is cut-out animation by scaling down the depth of the 3D shapes to make them appear like flat pieces of paper.

Software giant Adobe makes a vector-based animated software application called Flash, often used when creating animation for the Web or to digitally simulate a 2D, cut-out animated look in TV and feature film production. Because Flash is not pixel or raster-based, the images and animation created are very small in file size and therefore suitable for uploading to the

Web and allowing the user to download the animation relatively quickly. Vector-based lines are generated mathematically and never display the "jaggy," stair-step, irregular-looking outlines commonly associated with raster-based art.

To a certain degree, each and every film production requires a level of innovation, of figuring out the workflow and understanding and determining the steps necessary to create the finished film. Most animated productions nowadays use some form of 2D or 3D turnkey computer animation software, but there is always a necessity to invent the "look" of the film from scratch as well as to pioneer the proof-of-concept for how the film will actually get made. *Waltz with Bashir* was no exception to this, and Yoni Goodman had a great impact on the inventive way in which Flash was used to animate this project. He developed the idea for "breaking apart" lines and then reassembling the lines so as to create new animated shapes.

Interview

JK: *How did you first start working with director Ari Folman?*

YG: Ari had a live-action documentary series called *The Material That Love Is Made Of*, and we actually met through that project. It was a documentary that followed love stories, different types of love stories. The stories were funny, surreal, crazy; an assorted variety. For example, there was one story of first love, disappointing love, and another story of a boxer who appeared to be really confident but in reality was hiding behind his strength—very different types of stories. He wanted to start each one of the chapters with animation of interviews he had conducted with scientists who were talking about love, about the material that love is made of.

JK: *Why did Folman decide on animation for that series?*

YG: The scientists talked about how love is really just a bunch of chemical reactions and that there was no such thing as love. It's all chemical reactions in your head, stuff like that. He wanted to ridicule them. He came to David Polonsky [*Bashir*'s Art Director] and me and said, "Everyone tells me not to do animation. Everyone says it's awful, it's costly, it's horrible, don't do it!" But it was like an obsession for him. We took those interviews and made them as crazy as possible—there was lots of blood—very crazy stuff. It was very liberating. In the end we did around 16 minutes of animation. We got a great response to it, and even before we were finished with this project he came to us and said, "Listen, I've been thinking about making a movie about my experiences in Lebanon. Now I know how to work with animation." It just clicked.

And we worked so well together. We still are—we're now working together on the next feature.

JK: *Can you talk about the Flash technique you developed for* Bashir?

YG: It's very similar to regular Flash cut-out technique, but we took it a step further. In Flash, you can draw, for example, a head and make it a symbol and then have separate symbols for the eyes, a symbol for the mouth, and a symbol for the hair, and symbols for the eyebrows. This is basically what's done in Flash. We took it a step further by breaking each shape into more pieces. So you take the mouth symbol, for example, and go into the nested symbol and divide it into, let's say 10 or 15 pieces. So you have the main animation of the head, and then you also go inside each symbol and move those pieces.

JK: *Did you have to do any programming to get that to work?*

YG: Not at all; no programming. Just cut-outs.

JK: *So you were designing the symbols so that you could make different shapes with them?*

YG: Yes. I broke them apart— each piece has more pieces inside of it.

JK: *How is the animation in* The Material That Love Is Made Of *different from that in* Bashir?

YG: They both use Flash to create a cut-out animation style. In those days—this was around 2004—it was a very small industry in Israel, especially back then, and we had to work out a system that would produce fast, high-quality animation. *The Material That Love Is Made Of* was made with Flash cut-outs, and working on that project gave me ideas for how to do more elaborate things with *Bashir. Bashir*'s animation was much more complex. The style of animation in *The Material That Love Is Made Of* is more cartoony, everything is rough and rugged, but the cut-out basics are there. In *Bashir*, I took the technique up a notch.

The Power of Memory

What is memory? How are memories formed and how do we retrieve them? Our senses serve as strong conduits to memory. How is it that a sound or a smell can instantaneously trigger a memory, immediately bringing us back to another moment in our lives or to a powerful experience we once had? In *Waltz with Bashir*, director Ari Folman powerfully explores his own memory loss and recalls, in 2D animated form, the experiences of his life as a soldier. Folman journeys through his own post-traumatic memory losses by having conversations with other veterans and gradually unlocks his war-time experiences. Embraced by both the animation and documentary communities for its commanding blend of nonfiction storytelling with the animated form, *Waltz with Bashir* was nominated for an Oscar for Best Foreign Language Film in 2009. Yoni Goodman was Director of Animation and one of the lead artists who drove the look development and animation style of this ground-breaking feature-length animated documentary.

FIG 1.4
Printed with Permission, ©Bridgit Folman Films Gang LTD. 2009.

Interview

JK: *What was it like to work on* Bashir?

YG: We had a very, very small budget on *Bashir*. The entire budget was around $2 million. The animation industry in Israel is very slow; it's mostly about making commercials. We don't really have a strong tradition of making animated features. The first one was made with stop-motion puppets in 1962 by Yehoram Gross, who later went to Australia and became quite a big producer of animated content. So . . . there was quite a big gap between his feature and ours. I had a small crew of great animators, but none of them were that experienced with traditional animation. We couldn't afford people who could do clean-up, keyframes, color—in other words, the traditional animation pipeline.

David [Polonsky] has this amazing graphic line, and it was really hard to get experienced artists to draw this, so what we did was we took David's

illustrations and broke them apart into literally hundreds of pieces [in Flash], and then we just moved those pieces. That way, we moved David's illustrations—and that was the start of the film. The result was a sort of "strange" animation, and that, in a sense, was its power. If we had tried to make it look like very traditional animation, we would have failed. We didn't have the resources—and once we made this very "weird" cut-out technique when we were in the fundraising stages, we showed it to a few investors and some American producers who knew quite a bit about animation production. We pitched them a short test of what we had done, just to prove we could do it, and then we showed them something else—something which was a bit more elaborate and closer to traditional animation. They said: "We've seen tons of pitches which use traditional animation, but this other thing, we've never seen before." And that's the thing that's very strange, unique, and different about this film.

JK: *That's the charm of this movie; the fact that you can see the imperfection in the line.*

YG: Yes, that's the idea. The problem was that it was very technical. Nowadays we have a bigger budget and we're working on a new movie which will also be quite "strange."

JK: *Why was animation chosen for* Bashir?

YG: It was really the only way to show the movie. The alternative would have been to have taken a subject like that, the Israel-Lebanon war and the massacre at Sabra and Shatila, and the normal approach would have been to have taken these guys who are now forty-plus years old and have them sit in a sound booth talking about their experiences, then use archival footage and make a montage to try to get it as real as possible. With animation, you can do so much more. You can explore the emotions. If someone is afraid, you can show this feeling. If someone is hallucinating, you can show it. We never once considered making it a live-action film.

JK: *How do you think animation and documentary filmmaking strengthen and enhance each other?*

YG: Animation has a kind of "detaching" quality about it, so you can take the audience further. For example, the scene in *Bashir* where they're driving the wounded and the dead in the armored vehicles—these are extremely violent, graphic shots. Had the audience seen these in live action, they might have turned away. But people watched it. We intentionally played with this—making people see all these horrible things that happened during the war. As a viewer, you accept it—you tell yourself, this is animation, so you open yourself up to it. People saw more, I think, because we did it from this point of view.

JK: *In other words, you're saying that because the audience is looking at drawings or computer graphics, it's somewhat easier for them to take it in?*

FIG 1.5

Printed with Permission, ©Bridgit Folman Films Gang LTD. 2009.

YG: Yes, I think when you see something and your mind tells you: it's OK; it's not real, so you tend to open up. Then you think—wait a minute—this *is* real. It's something disturbing that I'm watching . . . but it already sunk in. You can open yourself up more to the subject.

JK: *Anti-Israel propaganda pervades much of the world. Do you think this contributed to some of* Bashir's *popularity when it came out?*

YG: No, definitely not. The funny thing is, though we always considered it a very left-wing movie, left-wing people had problems with the movie. The left-wing thought we got Israel off too easily, and the right-wing said, "You're selling us out." Such is internal Israeli politics. We were happy that both sides had problems with it; it shows that it was balanced.

Putting Israeli politics aside . . . this movie is not about politics. It's not about the politics of war; it's about a soldier's experience in war. It's about a regular person in an irregular situation. I went all over the world with this film, and audiences related to that point. I went to Korea, and they related it to the Korean War. I was in Serbia, and people could connect with it because it talks about human experience and not about political experience. I've never felt it was more or less popular because of political issues. We don't really say anything controversial because everything we talk about in the movie has been debated many times in Israel. This movie was about Ari's personal experience of the war, nothing more, nothing less. It's very subjective, but many people can relate to it.

JK: *Do you plan on making any more animated documentaries?*

YG: No, I try to do as many different kinds of projects as I can and not confine myself or limit myself.

FIG 1.6

Printed with Permission, ©Bridgit Folman Films Gang LTD. 2009.

Past, Present, and Futurological

Folman and Goodman are teaming up again on a new feature that's loosely based on Polish science-fiction writer Stanislaw Lem's novella called *The Futurological Congress*, which focuses on a futuristic drug-enhanced society. Best known for writing *Solaris*, Lem's themes include satirical looks at future utopian societies and are the source of inspiration for the creative combination of live-action with animation.

Interview

JK: *How far along are you in the production of* The Congress?

YG: The live-action footage was already shot in Los Angeles and in Germany and it stars Robin Wright, Harvey Keitel, and Paul Giamatti. The Congress is very different in every aspect from *Bashir*. I have my team in place and David [Polonsky] has his in place. We're currently working on the animatics.

JK: *What's the style of the animation going to look like?*

YG: Right now Ari's editing the footage, and I'm deep in the look development stage. Nothing is set yet—it's not going to be released until 2013, so it's still too early to have any finished images. The images that have already been put online are a more advanced version of what we did for *Bashir*, but they don't feel right so we're still exploring.

JK: *What sorts of things are you exploring?*

YG: Mainly movement. We're exploring traditional, frame-by-frame animation from the Thirties and Forties.

JK: *What's been your favorite project so far?*

YG: All of them. It's hard to say—well, *Bashir* was amazing. It was an amazing ride because I was part of creating a feature, and a fantastic subject. It was a dream come true in every aspect, and Ari's really amazing to work with because he gives you your space. You can have your say in almost anything, and it was an amazing process. I learned tons from it.

FIG 1.7

Printed with Permission, ©Bridgit Folman Films Gang LTD. 2009.

Breaking New Ground in an Ancient Land

The pioneering *Waltz with Bashir* was released to great acclaim around the world and still remains one of the strongest, most unforgettable examples of feature documentary films, animated or otherwise. Director Ari Folman publicly reveals his fears in this film, though he does so in a courageous manner by asking honest questions of himself, his friends, and his government.

This documentary is a mix of retrieved memories with artistic interpretation of wartime events. It was groundbreaking not only because it is one of Israel's only feature-length animated films, but also because it inventively and powerfully combined animation with nonfiction. *Bashir* was not motivated by politics, rather it was meant to be one soldier's painful and intimate view of his wartime experiences. Given the current multitude of war-torn locations, *Bashir*'s audiences resonated with its themes and were readily able to take in the animated content, its exploration of memory, and its unforgettable, haunting imagery.

With necessity being the mother of invention, Yoni Goodman pushed available software so that he was able to produce feature-level work effectively with a limited budget and creative staff. Goodman's understanding of animation as an art form and his trailblazing, inventive use of cut-out animation dramatically influenced the audience's perception of *Waltz with Bashir*, and continues to inspire and inform his current creative work.

In the end, this personal yet public documentary asks more questions than it can ever answer. Nonetheless, it is an important film. On day, perhaps, a film with the power of *Waltz with Bashir* will transcend the best foreign film or best animated film categories at the Oscars and simply fall into the best film category, fusing the various filmmaking communities even more closely together.

The Halfway Point to Reality: Bob Sabiston

Biography

Bob Sabiston and his company, Flat Black Films, have been making innovative animation since 1987. His student films from the MIT Media Lab, *Grinning Evil Death* and *God's Little Monkey*, were some of the first films to combine 2D and 3D computer animation. Sabiston's own films, including *Roadhead, Snack and Drink,* and *Grasshopper,* have been influential in the burgeoning field of animated documentary. Rotoscoped with a team of volunteers in Austin, Texas, *Roadhead* garnered a lot of attention on the film festival circuit. The short film *Snack and Drink* followed, a three-minute rotoscoped slice-of-life documentary that follows a young autistic man as he walks to a convenience store. *Snack and Drink* won several festival awards and became part of the Museum of Modern Art's (MoMA's) permanent video collection. It also tied with Pixar's *A Bug's Life* for second place in the 1999 Prix Ars Electronica competition.

FIG 2.1 Bob Sabiston.

Sabiston developed the computer-assisted rotoscoping technique for which Flat Black has become known. Dubbed "Rotoshop," it achieved international recognition through such films as *Waking Life* and *A Scanner Darkly*.

Director Richard Linklater's 2001 feature film *Waking Life* was lauded for its unusual plot structure and groundbreaking animation. The fluid interpolated shapes of Sabiston's rotoscoping technique were a perfect match for the film's philosophical, rambling dream world. Sabiston worked with a team of 30 artists in Linklater's office building for a year to create the film's animation. *Waking Life* premiered at the 2001 Sundance Film Festival and was released theatrically in October 2001.

In 2002, Sabiston was approached by Lars von Trier's company to participate in *The Five Obstructions*, a documentary feature film about filmmaking itself. Flat Black's five-minute animation segment helped director Jørgen Leth overcome the fourth "obstruction" laid out for him by the devilish von Trier. The film features a funny scene in which Leth visits the tiny Austin, Texas house occupied by Flat Black Films. During this time Flat Black Films also produced a half-hour of animated documentary segments for the PBS show *Life 360*.

In 2004, Flat Black began preproduction on a second feature film with Linkater. *A Scanner Darkly* is an adaptation of the novel by Philip K Dick. In contrast to Flat Black's previous work, which featured the varying styles of individual artists, Linklater wanted the film to have a single animation style. A team of 35 artists were recruited to do the highly-realistic style inspired by graphic novels. Sabiston also spent several months expanding his proprietary software to handle the film's more polished technical demands. Unfortunately, the studio's low $2 million animation budget and unrealistic five-month timeline led to recriminations and fighting between Sabiston and the studio. Three months into animation, Sabiston and his team left the production with ten minutes completed. Under threat of lawsuit, Sabiston agreed to let the studio use his software to finish the film. Ultimately, it took a year and a half, over 50 artists, and twice the original animation budget.

Following his exit from *A Scanner Darkly*, Sabiston took a commercial job—the Charles Schwab *Talk to Chuck* advertising campaign. The series of ads was quite successful, leading to 35 spots over three years. In 2009, however, the advertising agency replaced Sabiston and his company with a cheaper, filtered lookalike process. An attempt to legally prevent Schwab from copying the Flat Black Films "look" was not successful.

An accomplished graphics programmer, Sabiston also developed the iPhone mind-mapping program Headspace and the iPad construction program Voxel. Most recently, he celebrated the release of Inchworm Animation, an animation program for the Nintendo DSi.

The Art of Tracing

The technique of fusing the hand-drawn line with live-action footage has been around for a long time. Rotoscoping, or tracing over live footage one frame at a time, was patented by Max Fleischer, a pioneer in the world of animation, in 1915. In 1921, Max and his brother Dave founded Fleischer Studios and produced animated cartoons and short subjects. In modern times, rotoscoping has taken on a new popularity in numerous feature films and in commercials such as the Charles Schwab *Talk to Chuck* campaign.

As in many aspects of the art world, rotoscoping is not without controversy. When animated features such as *Snow White* were in production, filming the action of humans and animals was used so that the animators could study intricate movement as a reference for their animation. As Frank Thomas and Ollie Johnston (two of Disney's "Nine Old Men")[1] have described in their animator's "bible," *The Illusion of Life*, their rotoscope machine was a projector that had been converted to project one frame at a time onto a piece of clear glass mounted in a drawing board. Each frame of film could then be traced by placing a sheet of paper over the glass. Walt Disney modified this by having the film lab print out each frame of film onto photographic paper, which was the same size as the animation paper. These photostats, as they were called, were then hole-punched and made to fit the special pegs contained on the animator's desk. Animators could then flip through the photostats and really study the subtle nuances contained in the motion.

The live-action reference film for Snow White's character was acted out by a high school student named Marjorie Belcher, who was later known as the dancer Marge Champion. Frank Thomas and Ollie Johnston point out that nothing in the photostats could be copied or traced; they were there only as a guide to help the animators produce their work. The animators did not simply trace over the series of live-action stills but made their own drawings and emphasized the same actions seen in the photostats. Many animators (then and now) view rotoscoping as a "crutch" of sorts, much in the same way that motion-capture technology is frowned upon by many in the animation community. In fact, in the end credits of their feature work-of-art *Ratatouille*, Pixar states: "Our Quality Assurance Guarantee: 100% genuine ANIMATION! No motion capture or any other performance shortcuts were used in the production of this film."

Nevertheless, in many of today's films, rotoscoping is used not as a means of "hiding" the fact that live footage is traced, but rather as a starting off point in more experimental films such as those produced by Bob Sabiston and Flat

[1] The "Nine Old Men" were a group of core animators who created some of Disney's most well-known feature animated films.

Black Films. In these cases, the artists go beyond the rotoscoped look and add their own unique artistic vision to the projects.

Interview

Judith Kriger: *In film school I was taught that the technique of rotoscoping entails the frame-by-frame tracing of filmed images. From watching* Waking Life *and* A Scanner Darkly, *I have come to understand this term in different ways. How would you define rotoscoping?*

Bob Sabiston: I think of it in the same way, essentially: tracing over live action to create something animated. However, the software we use does eliminate the need to draw every single line of every single frame; instead, lines and shapes can be linked across frames and "interpolated." This saves time and also gives the resulting animation a smoother look than that of traditional rotoscoping. But essentially it is still hand-tracing over photography to me.

JK: *Do you think audiences would react differently to your films if they didn't use rotoscoping and were purely live-action?*

BS: I don't know that the films would work. I'm coming at it from the point of view of wanting to show something visual; my whole reason behind these films is the animation. I'm looking for something that is worthwhile to animate. Animation takes a long time and is a great effort, so you don't want to spend your time working on something that isn't important to you. The subject of these documentaries is just the means to determine whether or not I can find something that is meaningful to animate. I don't know if the subject without the animation would stand on its own; at least I don't think of it in that way. I can tell you that watching *Waking Life* as a live-action movie . . . is kind of . . . painful. <laughs>

JK: *What do you think the hand-drawn line does to documentary films? What is it about this "look" that's so appealing?*

BS: There's an interesting thing that happens. When you draw someone and you hear their actual voice but you're not exactly seeing their real face—you're seeing someone's interpretation of their face—it does two things. A lot of people have mentioned to me that they're actually able to pay more attention to the words being spoken because they don't make snap judgements about the person's appearance. A lot of times when you see a talking head, there's some subconscious thing that goes on where you're interpreting what they're saying—you're incorporating what you think of them visually. You're filtering what you think about what they're saying based on how they look.

The second thing that happens is that you get the animator involved; you have this other personality layered on top of the subject. It's a sort of

commentary—in other words, what does this animator think of this person? A lot of times what you see is a sort of melding of the two personalities. I work with a lot of the same artists over and over, and you can tell which animator did which section because of their particular style. When you get a good match between the artist and the subject, I think it makes for a more powerful experience to the viewer. *Waking Life* was primarily about the contribution of each animator's visual style to the movie—the artist's viewpoint—and mixing this with the different characters' philosophical viewpoints.

FIGS 2.2 and 2.3 Stills from *Project Incognito*. Animation by Bob Sabiston and Malissa Ryder.

Finding the Right Stranger

Interview

JK: *Who or what influences you?*

BS: As far as influences in the documentary animation field, it's sort of split into different camps. I first got into animation probably from the earliest Pixar shorts. When I was in college, I went to one of the SIGGRAPH festivals, which is a computer graphics conference, and they had Pixar's shorts *Luxo Jr.* and *Red's Dream*. Those were very inspiring to me, and I went back and spent my whole junior year in college just trying to make a short to get into SIGGRAPH the next year. And then a couple of years later I really got into documentary filmmaking. I'd say Errol Morris' work—I especially love *Vernon, Florida* and *Gates of Heaven*—made me decide to want to combine the two. It was actually many years later that I got into doing that with an MTV contest. I was actually just trying to do regular animation for a while. There's one other thing that was a big influence on me: the Aardman Animations short *Creature Comforts*: it sort of combined documentary sound with clay animation, which is so effective.

JK: *What is it about the documentary genre you fell in love with?*

BS: For me, it's mostly about the artwork and the animation. I've just always grown up being interested in art and computer graphics.

Documentary was a way to showcase what I was interested in with art, by tying it to people's personalities. That's why I mentioned Errol Morris. His early films don't have much of a subject—he's just sort of taking a look at what's interesting about people's personalities. His early films are about weird people. Though there sort of is a subject, it seems that mostly they're an excuse to present these quirky personalities. They really appeal to me; I'm not really interested in documentary just as a form of exploring a subject. What interested me is how Morris is interested in exploring these kinds of funny, weird personalities. To me, looking at people's facial expressions when they talk is a good subject for artwork. It's not so much about the subject matter; it's more about the realistic qualities of people and how they act. It seemed like an appropriate thing for animation because we're caricaturing people without really seeing them, so in a way we're also protecting them. It's sort of a filter. It's interesting to me because we're interpreting someone's personality, but in a way we're also hiding them. I think that's where that interest came from. Also, I don't feel that I have a particular talent or desire to write fiction, but the idea of going out and interviewing people in real life or discovering real-life personalities is something which both interests and challenges me.

FIGS 2.4, 2.5 and 2.6 Stills from *Grasshopper*. Animation by Bob Sabiston.

JK: *You've talked about selecting the "right stranger" for your interviews. How do you go about defining and selecting the right stranger?*

BS: We did a whole bunch of interviews in Washington Square Park in New York City, and that was a case of just looking at people. In that park there are tons of people who are just walking by all the time; it was a case of figuring out who was approachable. I didn't go about it with anything particular in mind. It was more about picking someone who looks like they're not going to get angry if I approach them. For me it was kind of a challenge. I'm a very shy person in general, so if I approach a stranger and try and interview them, I would be investing a lot of energy into them and hopefully they could feel that and then we could get an interesting conversation going. There wasn't anything particular about the people I approached; it was more about "Let's approach everyone I can and see what kind of interesting, everyday moments can potentially crop up."

FIGS 2.7, 2.8 and 2.9 Stills from *Grasshopper*. Animation by Bob Sabiston.

The Challenge of Merging Media

Fusing documentary with animated filmmaking necessitates discovering the common ground between the two genres so as to create an effective mashup. The director must determine the content of the film and be mindful of the design of the look development in such a way as to still retain the respective integrities of both. Does the style suit the story? Will a particular trend or visual technique distract the audience from the narrative?

Interview

JK: *In many of your films, some of the facial features sort of "float off" the person's face. From an artistic or director's point of view, when do you do that, or why do you do that? What do you bring out in the story by doing that?*

FIGS 2.10, 2.11 and 2.12 Stills from *Road Head*. Animation by Bob Sabiston.

BS: I think because it started out as portraits of people's personalities—sort of like a moving life drawing—I come at it from a perspective of what's interesting visually. That kind of thing usually just happens in the moment, while you're sitting there working. I think a lot of the initial projects we did were about freedom to the animator. It's important to me to let the artists have creative freedom. I always disliked the whole storyboard/model sheet idea of taking artists and making them draw a certain way. It's kind of a double-edged sword, because some animators don't do what you want them to do. But I've learned that trusting other animators' intuition is usually more valuable than trying to insist on mine.

FIG 2.13 Still from *Road Head*. Animation by Mike Layne.

JK: *What attracted you to the* Snack and Drink *story?*

BS: I was in a coffee shop in Austin and got to talking with this woman who suggested that I interview her autistic son because he's obsessed with cartoons. She thought that if I turned him into a cartoon, it would help him in some way. He wouldn't sit down for an interview, but he did say that we could follow him as he went to get a snack and drink at the local 7-Eleven. That was my first experience with someone with autism, and it seemed like a natural subject for animation. It shows how he sees the world: lots of colors and fractured looks. He's also in *Waking Life*.

FIGS 2.13A and 2.13B Stills from *Snack and Drink*. Animation by Bob Sabiston.

FIGS 2.13C and 2.13D Stills from *Snack and Drink*. Animation by Bob Sabiston.

FIG 2.13E Still from *Snack and Drink*. Animation by Jennifer Drummond.

FIG 2.13F Still from *Snack and Drink*. Animation by Constance Wood.

JK: *Would you say you're more of an experimental filmmaker?*

BS: Yes, I would say I am, as far as the animation goes. I'm more interested in adhering to a set of principles and not caring as much about what the film turns out as. It changes a little bit with each project. With my earlier projects, I didn't care what the film looked like: I just did it in that way because it was the fun way, and those were relatively successful. But then as things went on, there was a little bit of pressure for things to look better. When you're working for someone else, they want it to look a certain way, so other factors come in. Also, you just kind of get tired of doing the same thing, so I do think there's a bit of experimentation in what we've done.

FIGS 2.14 and 2.15 Stills from *The Even More Fun Trip*. Animation by Randy Cole and Patrick Thornton.

 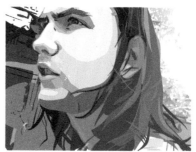

FIGS 2.16 and 2.17 Stills from *The Even More Fun Trip*. Animation by Bob Sabiston and Susan Sabiston.

Waking Life and *A Scanner Darkly*

Though it technically does not fall into the category of nonfiction filmmaking, *Waking Life* was revolutionary for its time due to its dreamlike, surreal documentary tone. Rotoscoped versions of Timothy.

"Speed" Levitch (who at the time was an eccentric New York City tour bus guide) and idiosyncratic directors Caveh Zahedi and Steven Soderbergh appeared in the film. Their oddly unique personalities combined with Sabiston's fluid, otherworldly rotoscoping effect added to the visual non-sequiturs of this award-winning feature. In 2002, Sabiston was nominated for the American Film Institute's Digital Effects Artist of the Year award.

Waking Life's inspiration originated, in part, from the Spanish philosopher and poet George Santayana's principle: "Sanity is a madness put to good uses; waking life is a dream controlled," a quote from "The Elements and Function of Poetry" in Santayana's book *Aesthetics and the Arts*. Director Richard Linklater's rotoscoped feature focuses on an unnamed young man played by Wiley Wiggins as he searches for answers to life's most important questions.

The artistic and technological connection between Max Fleischer and more modern uses of rotoscoping include several feature films produced by Ralph Bakshi, who in his early career became producer and director of Famous Studios, formerly known as Fleischer Studios. Bakshi is best-known for directing the first X-rated animated film, *Fritz the Cat*, and his rotoscoped filmography includes *The Lord of the Rings* (1978) and *American Pop*.

Given that rotoscoping entails tracing live footage, one could argue that it has a close first cousin in motion capture. Mocap footage is plugged into 3D models that are in turn used in verything from feature animations to visual effects, TV shows, commercials, and games.

Celebrated science-fiction writer Phillip K. Dick wrote the novel *A Scanner Darkly*, on which Linklater based his dark, edgy feature film of the same name.

Interview

JK: *Of the commercial projects you've worked on, which has been your favourite?*

BS: *Waking Life* was the most thrilling and fun. I'm a huge fan of Richard Linklater; he's a great inspiration to me as a filmmaker. When I was 23, I must have seen *Slacker* 10 times.

JK: *What appealed to you about that movie?*

BS: I think it just presented a picture of life that was so different than the one that I had just spent in college, locked up in a computer lab. I wanted to "live" in that movie and be that kind of person. I think that movie had a big influence on my moving to Austin; I wanted to move to Austin and be a slacker. *Waking Life* is a similar movie to *Slacker* in that it's a big thrill to have been a part of that. To then have been in charge of all the animators was an amazing experience.

JK: *The backgrounds (in* Waking Life*) often lose their registration and seem to break apart from the rest of the frame. Was this meant to convey Wiley's character's disconnect from his world? Can you talk about this artistic decision?*

BS: I wouldn't call that a decision so much as an accident or a technological limitation that turned out to conveniently work for the movie. When I first developed the software, I only wanted to animate people's facial expressions, and for that, we only really needed the interpolated lines.

However, as we began to use the software for more film shorts, it became desirable to fill in the entire frame. Objects, cars, buildings, all these things that didn't change shape suddenly needed to be animated as well. I added the ability to draw a static object and position it with keyframes throughout the scene—what I called the *South-Park* style, because it is like sliding around paper cut-outs. This feature was already clunky to begin with, and when put to use by a lot of artists with limited computer experience, the effect was quite wobbly. But like I said, the whole movie was a dream, so it ends up contributing to that unreal feeling.

JK: *Can you describe what the production process was like on* Waking Life?

BS: It was fortunate because it was a natural outgrowth of the way we had been working before: I hire a team of animators and then give them relative freedom to do what they want on their sections of the film. Richard [Link-later], the director, was fine with that: in fact, [*Slacker*] really benefitted because it's made up of sequences of a variety of people throughout the film. There's one central character, but other than that, each person shows up for a couple of minutes and then disappears. So we decided at the very beginning that we would do a similar approach. Each animator would basically get one character in an entire scene, and he or she would develop

a "look" for a particular scene. The animator would take the time to animate it, and when they finished, they would go on to another character. The movie was completely edited before we started, and I let the animators choose which scenes they wanted. If it happened that more than one person wanted the same scene, I had them draw sample still images of what their scene would look like and presented the stills to the director.

We had 16 Macintosh G3 computers and we had 30 people, so the schedule was broken up where most people worked 20 to 30 hours per week. As the production process went on, I developed a lot of software for assembling their scenes and keeping track of the whole movie, so that as people finished a section, I could write it out to the main movie. At any one time, we could copy this giant QuickTime over to an external hard drive and then watch the movie in progress. It turned out to be a pretty fluid way of working. *Waking Life* was one of the first, if not the first, movie to be edited with Apple's Final Cut Pro. I remember the producers spending a lot of time with the Final Cut people because it was pretty early on in its use for film production.

JK: *The line quality in* A Scanner Darkly *was much tighter, and for the most part it describes a more accurate depiction of the live footage. What was the intention of this line quality versus that of the line quality in* Waking Life?

BS: Although the interpolation allowed us to be quite accurate with faces and people's movements, for *Scanner* we wanted to improve upon *Waking Life*'s wobbly handling of static objects and backgrounds. I ended up writing a lot more software for *Scanner*, including the ability to transform static objects by keyframing the vertices of their enclosing quadrilaterals. This let us approximate perspective shifts and more accurately track a drawn object to its live-action source.

More importantly, *Scanner* has a much more conventional story structure than *Waking Life*. No one thought that it would work to have the styles changing every five minutes whenever another animator took over. To that end, we spent a lot of time auditioning and assembling a team of animators—primarily illustrators and comics artists—who we felt would excel at the more graphic-novel style we wanted. The style is considerably more detailed, as well, with a lot more shading: this was just a way of "upping the ante" visually, so to speak.

JK: *Would it be fair to describe* A Scanner Darkly *as a rotoscoped film?* [*i.e. as opposed to describing it as an animated film*]

BS: Of course. That touches on a point that comes up a lot. I think a lot of people get hung up on whether or not it is "cheating" or "fair" to use rotoscoping. There's no question that rotoscoping is easier to do, and it can be used as a crutch. But in my opinion, with our type of rotoscoping, you can do things that would simply not be possible with traditional

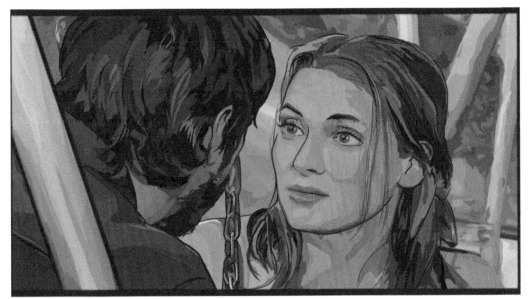

FIG 2.18 Donna, outtake from *A Scanner Darkly*. Animation by Bob Sabiston.

animation—sometimes with considerably less effort. Some critics also believe that our work is done using computer filters or some kind of auto-mated process instead of hand-drawing. If that were the case, I wouldn't really be interested in doing it.

Also, the people criticizing rotoscoping are often being hypocritical, in my opinion. Animation is supposedly this exalted high art form, but look at what it gets used for: primarily cliché-ridden, derivative, and mindless kiddie entertainment. If it is so respectable, people need to use it for something worthy of respect. The reason that they don't, I feel, is that it is so time-consuming and expensive. Studios cannot afford to risk it on anything other than what they can count on taking to the bank.

You just have to take the entire film into consideration: Is the filmmaker just trying to get out of doing hard work, or is he or she trying to do something new or different? I'm not sure that *Waking Life* and *Scanner Darkly* would be very good if they were traditionally animated. They need to be in that halfway point to reality.

JK: *Do you think animated docs can be made using techniques other than the hand-drawn line?*

BS: Yes, I don't think it really matters. It's just an alternative visual repre-sentation that goes along with the audio. I don't think there's a reason why it has to be a line. The line has its own particular qualities, but so do other techniques.

Dogma at 24 Frames per Second

In 1995, Danish directors Lars von Trier and Thomas Vinterberg created an avant-garde filmmaking movement known as Dogme 95 ("dogme" Danish for "dogma"). Their goal was to purify the filmmaking experience by concentrating on the story and the actors' performances. Their principles, known as the "Vow of Chastity," did not allow for the inclusion of special effects or postproduction techniques, and they intentionally did not seek financing from huge, Hollywood studios. How, then, did Von Trier end up directing an animated film?

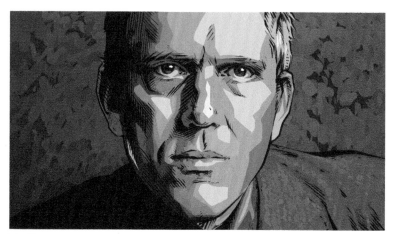

FIGS 2.19–2.29 Stills from *The Five Obstructions*. Animation by Patrick Thornton, Randy Cole, Katy O'Connor, Bob Sabiston, Susan Sabiston, and Jennifer Drummond.

FIGS 2.19–2.29 Continued

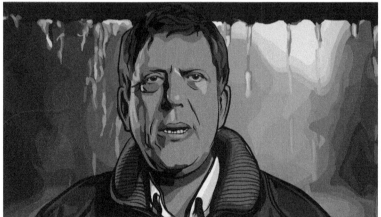

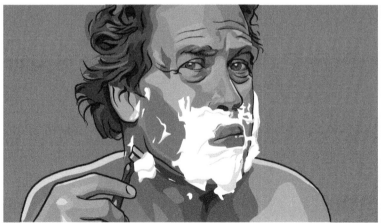

FIGS 2.19–2.29 Continued

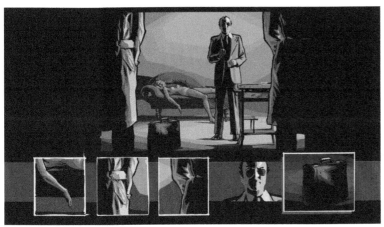

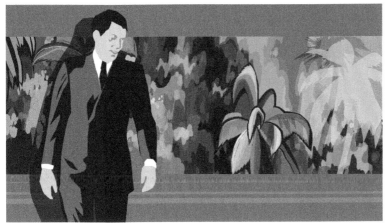

FIGS 2.19–2.29 Continued

JK: *How did your involvement with* The Five Obstructions *come about?*

BS: I got a call out of the blue asking if we could do five minutes of animation for a Lars von Trier film: I said, "Yes!" The main premise of the film is that Lars von Trier challenged his old college professor, Jørgen Leth, a well-known director of experimental documentary films, to remake an influential film he had made in the Sixties called *The Perfect Human* in five different ways. The catch was that Lars came up with five "rules," which would make it almost impossible for Jørgen to make a good film. For example, one of the rules in this challenge was that the film had to be made in the most uncomfortable place on earth, so Jørgen ate sushi in front of a bunch of starving people in Bombay. Another rule was that it had to be a cartoon. Von Trier did that because they both hate cartoons and animation. Someone had seen *Waking Life* so they called us to do the animation. Though they didn't like animation, they did like comic books and the paintings of Francis Bacon, so these were the artistic references we used on this film.

Creativity in Coding

Interview

JK: *Are you currently interested in developing a new "look" for animation?*

FIGS 2.30 and 2.31 Stills from animation created with Line Research software.

BS: I'm always interested in that sort of thing. I've got another piece of software called Line Research that's based on abstract art. I'm interested in exploring this idea of, What if you could create animation in the same way that musicians create music, with instruments? I've been trying to figure out why music is so emotionally effective in a way that the visual arts are not. I'm wondering if that's because music is created in real time, as a performance. Based on that idea, I started writing software where the computer is recording what your hand is doing, and your hand is controlling different types of brushes. The brushes are like instruments. Instead of doing animation frame by frame in a very static way, it's doing it as a live recording of a performance. With the other hand you control the colors and sizes of the brushes. I tinker with it every now and then; it's not really for commercial purposes, it's more abstract. It's a new way of doing artwork that I haven't seen before.

FIG 2.32 Still from animation created with Line Research software.

JK: *What kinds of projects are you currently working on?*

BS: I've been doing a lot of computer programming. I have these two iPhone apps that I've been bouncing back and forth between, and I have some animation software called Inchworm Animation that I've written for the Nintendo DS. I started working on it as a hobby about five years ago. We were off *A Scanner Darkly*, and I always had an interest in writing a game for a handheld gaming system. I had been playing around with the Gameboy Advance when the Nintendo DS came out. When it did come out, it really

inspired me to get into it more heavily because it has two screens, one of which is a touchscreen with a little stylus. Nowadays, everything has a touchscreen, but five years ago it was a very new thing. I wrote to them and asked if they'd let me be a developer so that I'd have access to the tools, and it became a sort of hobby to write a paint or animation program for this kind of a handheld system. I grew up with video games; they've been a pretty big part of my life, so it was an interesting pastime.

As it went on, I got more serious about it and tried to get a publisher interested. I tried to get Nintendo interesting in publishing it themselves; but no one was really interested because it's not a game, and that's the only thing that's really been proven to sell on those systems. It's a mini Photoshop or Flash animation type of program for a portable device; it's not a game. It also has a built-in camera, so it really lends itself to rotoscoping or taking pictures and animating on top of them. They finally came out with this downloadable service where individual developers could publish their own projects without having to have a publisher. I had kind of given up on it, but when they announced that in 2009, I realized that I didn't need a publisher and just had to buckle down and finish the whole thing myself. All the other software I've written has just been for myself and/or my studio, which means that if it doesn't work or if there are bugs, I can fix them. With Inchworm, on the other hand, it's a very different experience, because it's a published thing and after you publish it you can't go back and change it.

JK: *So it's an app that people can buy?*

BS: Yes, it's very much like an iPhone app, except that it's for the Nintendo devices and they have their version of the App Store called DSiWare; the Inchworm Animation app is available there.

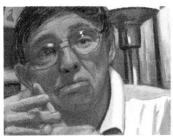 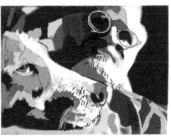 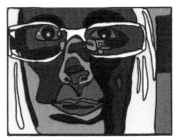

FIGS 2.33, 2.34 and 2.35 Stills created with the Inchworm Animation app.

BS: Also, Flat Black Films is currently producing five independent short animations being directed by long-time lead animators Jennifer Deutrom, Randy Cole, Katy O'Connor, and Patrick Thornton. The first of these, Deutrom's *Get With the Program*, premiered at SXSW '11 and is making the festival circuit. I've also contributed animation to the films of several director friends, including Caveh Zahedi's *I Am a Sex Addict* and Bob Byington's *RSO*

[Registered Sex Offender]. My company is currently animating segments for Byington's upcoming feature *Somebody Up There Likes Me*.

JK: *It sounds like you've done a fair amount of software engineering. Do you have a background in programming?*

BS: Yes, I've been doing programming since I was a little kid. It's played a part in all the filmmaking I've done as well. With most of the animated films I've made, I've started out wanting to show off a piece of software. It's very tied together for me; my programming is always directed towards producing some kind of artwork.

JK: *How did you come up with the idea to develop your Rotopaint software?*

BS: I started off wanting to do a traditional rotoscoping approach, where I wanted to be able to take some video on a computer and step through it frame by frame and just draw on each frame. If you know graphics programming, that's a pretty simple program to write. At that time, back in 1997, MTV was looking for submissions for a contest; *Beavis and Butt-Head* had just ended and they were looking for ideas for a new show. The contest required a 90-second submission of a character talking to the screen about him or herself. I decided I didn't want to go and invent a character; I just wanted to find real people that I thought were interesting, and animate them. I was surprised to learn that there wasn't any rotoscoping software available, and that's when I decided to write my own. In the course of doing that, I found myself drawing the same lines over and over again, so it was a very easy step to have the computer interpolate that. As a result, the animation looks simultaneously realistic and unrealistic.

FIG 2.36 Still from *Topic Pot Pie*. Animation by Randy Cole.

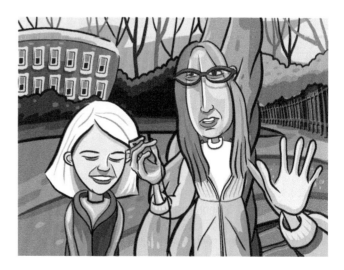

FIG 2.37 Still from *Topic Pot Pie*. Animation by Nathan Jensen.

Leading the Fleischer Legacy into the Digital Age

If imitation is the highest form of flattery, then Bob Sabiston and Flat Black Films must be feeling quite praised. His important development and modernization of the Fleischer rotoscope technique into the Rotoshop style has significantly influenced many filmmakers who are considering the possibilities of fusing animation with documentary filmmaking. Though Sabiston's proprietary software and resulting artwork is more complex and detailed, filmmakers have the ability to outline live-action footage using popular professional applications such as Adobe After Effects, bringing rotoscoping into the 21st century and enabling this technique to be easily accessible and allowing for its continued popularity in TV as well as feature film production.

Personal Documentaries:
John Canemaker

Hand-drawn animated techniques are seldom spoken about in our digital age, but the truth is, CG and visual effects owe their very existence to this art form. The zoetrope, phenakistoscope, and stroboscope demonstrated "persistence of vision," a principle pointing out the brain's ability to hold still images together long enough so as to believe the images are actually in motion. These parlor toys from the 1830s required the viewer to look at images through rotating slits, while Émile Reynaud's praxinoscope used mirrors to reflect drawings inside a revolving drum. Related to this is the traditional animation technique of "flipping through" stacks of animated drawings so as to be able to gauge things like timing and posing, just two of the ingredients that make for appealing animated films. Although today's hi-end software has the technical ability to "in-between" or interpolate between the key storytelling drawings or CG poses, it is the

FIG 3.1 Photograph of Academy Award and Emmy Award-winning director/designer/animator John Canemaker.

animator's artistic talents that really design the fluidity of the motion and the emotional impact of the animation.

Biography

An Academy Award-winning independent animator, animation historian, teacher, and author, John Canemaker has screened his work to great acclaim at film festivals, museums, and universities around the world. Canemaker's films move the art of animation forward because of their raw honesty and ability to speak to the emotional core of the story.

His personal films, which are part of the permanent collection of the Museum of Modern Art (MoMA) in New York, are collected and distributed by Milestone Film & Video/Image Entertainment on a DVD/home video release entitled *John Canemaker: Marching to a Different Toon*. Not only has Canemaker made animated films and animation for documentaries, but he has also made documentaries about animators, such as *Otto Messmer and Felix the Cat*, *Remembering Winsor McCay*, *The Boys from Termite Terrace*, and *Chuck Jones: Memories of Childhood*.

He is also a full professor and director of the Animation Program at New York University Tisch School of the Arts. In 2009 he received the NYU Distinguished Teaching Award for "exceptional teaching, inside and outside the classroom."

Canemaker won a 2005 Oscar and an Emmy Award for his 28-minute animated short *The Moon and the Son: An Imagined Conversation*. He also created animation for the Oscar-winning documentary *You Don't Have to Die* (HBO); the Peabody Award-winner *Break the Silence: Kids Against Child Abuse* (CBS); and the 1982 feature *The World According to Garp* (Warner Bros.).

Canemaker has written ten books on animation history on subjects ranging from Winsor McCay and Felix the Cat, to Tex Avery and numerous Disney artists that are among the most important and thoroughly researched in the field. His latest book is *Two Guys Named Joe: Disney's Master Animation Storytellers Joe Grant and Joe Ranft*, published by Disney Editions.

His monthly blog, Canemaker's Animated Eye, for Print Magazine Online (http://imprint.printmag.com/john-canemaker/), explores the relationship between fine art and animation. In 2008, the Museum of Modern Art featured Canemaker's 1998 short film *Bridgehampton* in its Jazz Score show, with screenings throughout the day and original animation art from the film on exhibit in the gallery.

Canemaker was awarded an honorary Doctor of Fine Arts degree from Marymount Manhattan College in 2007 and, for his work as an animation historian, a special honor from the 2006 Zagreb Animation Festival and the

2007 Jean Mitry Award from Italy's Le Giornate Del Cinema Muto. In 2007 the International Animated Film Society, ASIFA-Hollywood honored Canemaker with the Winsor McCay Award, in recognition of his career contributions to the art of animation. He has also received two residencies from the Rockefeller Foundation's Bellagio Center.

FIG 3.2 Selected pages of drawings for early thumbnail storyboards of John Canemaker's *The Moon and the Son: An Imagined Conversation* (originally titled *Calabrese: Confessions of My Father*), dated August 1999, made during a one-month residency grant at the Rockefeller Foundation's Bellagio Center in Italy.

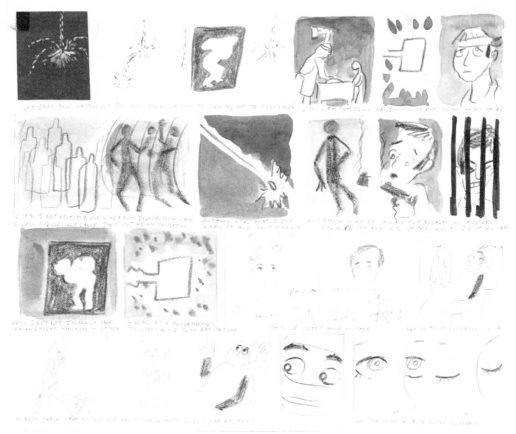

FIG 3.3 Selected pages of drawings for early thumbnail storyboards of John Canemaker's *The Moon and the Son: An Imagined Conversation* (originally titled *Calabrese: Confessions of My Father*), dated August 1999, made during a one-month residency grant at the Rockefeller Foundation's Bellagio Center in Italy.

Parents and Children

The Moon and the Son: An Imagined Conversation is John Canemaker's Oscar-winning animated film about his relationship with his late father. Poignant and at times painfully humorous, the film is a deeply intimate look inside the filmmaker's early family life. Using sequences of hand-drawn animation integrated with photos and actual newspaper headlines about his father, *The Moon and the Son* tells the story of an invented, though intensely desired, conversation Canemaker has after his father's death in 1995. Through narration, the filmmaker asks many questions of his father and is not always supplied with the most comforting of answers. Given the state of affairs described in the film, it is easy for the viewer to connect with the filmmaker's combined sense of frustration, distress, and grief at having grown up in often chaotic family circumstances beyond his control.

FIG 3.4 Rough models for Italy sequence of "Dad as boy," dated January 3, 2001.

FIG 3.5 Rough idea sketches for the "1950s Dad," dated December 31, 2000.

Interview

Judith Kriger: *In* The Moon and the Son: An Imagined Conversation, *you reveal a very personal, and at times, painful story. What was your purpose in making such an intimate project?*

John Canemaker: The purpose was to tell my story truthfully, in animation. Through the years, I have told other people's stories in ten books and numerous periodical articles on animation history; in sponsored films, such as *You Don't Have to Die* (HBO, 1988 Academy Award-winner), or *Break the Silence: Kids Against Child Abuse* (CBS, 1994, Peabody Award-winner), or *John Lennon Sketchbook* (Yoko Ono, producer, 1986); and in my own independently made shorts, such as *Confessions of a Stardreamer* (1978), or *Confessions of a Stand-Up* (1993). There were also my documentaries *Otto Messmer and Felix the Cat* (1977), *Remembering Winsor McCay* (1976), *The Boys from Termite Terrace* (CBS Camera Three, 1975), and the recent TCM special *Chuck Jones: Memories of Childhood* (2009).

My story, which had been brewing in my mind for a number of years, came together when I was awarded my first residency grant in Bellagio, Italy, from the Rockefeller Foundation in 1999.

JK: *Who or what inspires or influences you?*

JC: In my teaching at NYU, I show my animation students works in many art forms and relate great stage and film performances, graphic and fine arts, music, poetry, dance, and mime to animation by finding levels and similarities in communication principles common to all art forms. There are so many (too many) artists I admire and find inspirational. Among a very eclectic list in no particular order:

Charles Burchfield; George Dunning; Lena Horne; Fred Astaire; Bill Peet; Frank Thomas; Vladimir Tytla; Oskar Fischinger; Fellini; Orson Welles; Elaine Stritch; Milton Avery; Giotto; John and Faith Hubley; Judy Garland; Charles Laughton; Janet Malcolm; Jimmy Savo; Nureyev and Fonteyn; Walt Disney; Harvey Kurtzman; Winsor McCay; Bill Evans; Bill Traylor; Theodoros Stamos; Bert Lahr; Chuck Jones; and on and on . . .

Animation in documentary is not new; over the past decade we have seen such works as Brett Morgen's *Chicago 10*, Michael Tucker and Petra Epperlein's *The Prisoner: Or How I Planned to Kill Tony Blair*, and Richard E. Robbins' *Operation Homecoming: Writing the Wartime Experience*. These are examples of documentary filmmakers who have incorporated animation in their work, whereas Canemaker is an animator who incorporated a documentary sensibility into *The Moon and the Son* so as to arrive at a deeper truth.

JK: *You've worked with such documentary filmmakers as Bill Guttentag and Malcolm Clarke (*You Don't Have to Die*) and Melissa Jo Peltier (*Break the*

FIG 3.6 Sketch for a "happy memory": "pennies from heaven" scene.

FIG 3.7 Selected pages of drawings for early thumbnail storyboards of John Canemaker's *The Moon and the Son: An Imagined Conversation* (originally titled *Calabrese: Confessions of My Father*), dated August 1999, made during a one-month residency grant at the Rockefeller Foundation's Bellagio Center in Italy.

Silence*). What did you learn from those experiences, and how did working in documentary help shape your own artistic sensibilities?*

JC: Well, that's true. I have made documentaries for people outside of the animation community. The first question I ask documentarians when I come on a project is "Why do you want animation in this?" There really has to be a very good reason for using animation in documentaries, because they're really two different animals, in a way. But if you have a good reason to use it and you blend it together well, it can work and be really powerful. For example, *You Don't Have to Die* was an HBO special that was about a child who had cancer and won an Academy Award. It was actually based on a children's book and so the drawings could be adapted quite easily to animation and incorporated into it because it's part of this child's story. Also, the graphics were childlike, and they fit

very well. We had to find the right places for animation, and I think we ended up with about 6 minutes. You really don't need a lot of animation because it's such a concentrated medium; it's so powerful. But if you put it in the right places, it really works; it extends what can be done in live-action.

FIG 3.7A Ideas for turning letters of "No good!" into a monster, dated August 3, 1999.

I also worked on a film called *Break the Silence*, which was a film about child abuse; it was a CBS film. Animation is something which can personify thought, it can become emotions. I talked with them about finding the places where we could do that. They said, "Yes, because we don't want to show the abuse as it happened, we want to show how it felt to the children." We were able to do that—when a child was being set upon by his father, being beat up by his father with a belt—I created an octopus that had many belts on its "hands" and would chase after the children and would swing these huge belts at the children. That gave a psychological aspect to it. When a little girl was sexually abused, I was able to do research and found out that the people who draw their trauma—both children and adults—have several motifs. Some are genitalia, some are giant eyes because there's no privacy, and some are drawings of hands. From that research, I was able to put together this huge blue hand that comes into the child's bedroom, steals the covers off her bed, takes the teddy bear and throws it away, and then just covers over the child with the giant hand. That's something that's pretty scary to even talk about, but in the animation we were able to at least show the abuse as it really happened and the psychological side of it. That helped me very much when I did the *Moon and*

the Son, because I was always looking for symbols that empowered how it felt to me, and based on my experience with documentaries, I was able to incorporate symbols into the film.

FIG 3.8 The first page of the 15-thumbnail storyboard "suggestions"; the beginning of *The Moon and the Son*, dated July 21, 1999. Most individual story sketches are approximately 2½ by 3 inches, cut out and taped to larger sheets of paper.

FIG 3.9 Two finished drawings of a color change effect when the turtle bites his son's finger. White Prismacolor pencil and red gouache on textured black paper.

I like biographies, for the most part. I recently read a biography of John Cage and am reading a biography of Cleopatra. I'm just interested in people. In my books, I interview people and find out about them. I'm working on my 11th book now, about animation history. Basically, my books are biographies, and I've always been interested in people. When I was a kid in Elmira NY, I would go to the library and look up biographies, *Who's Who*; there's a certain point where the people became who they were supposed to be. I was always interested in that point of no return, where they became who they were. I'm fascinated with people, I like interviewing them and writing about them. My film was really coming from a writer's point of view in terms of trying to find out things about my father, about myself, and trying to keep an objective point of view.

FIG 3.9A Three sequential idea sketches for the "family" in the abstract section of the film, dated August 3, 1999.

JK: *Did you ever consider doing* The Moon and the Son *as a live-action film?*

JC: Never. I'm a dyed-in-the-wool animator. That's what I love and that's what I like to do. Of course I love live-action films—but not to make them. I think there's so much more for me to learn in animation. We only have one life . . . <laughs>

JK: *Yes, and producing animation takes up quite a bit of it.* <laughs> *How does combining animation with documentary filmmaking make the film more effective? How do the genres strengthen and enhance each other?*

FIG 3.10 Poster for Cinemax/HBO's cable television presentation of *The Moon and the Son* (completed 2004), air date June 18, 2006.

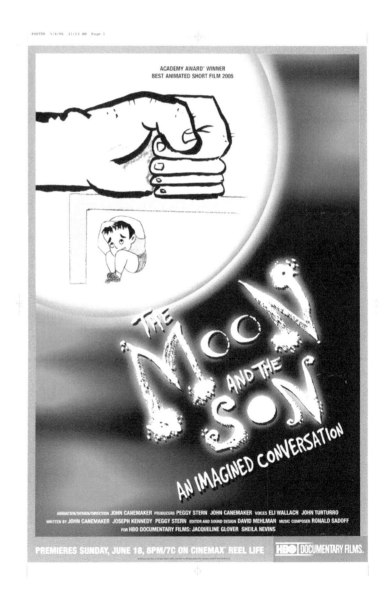

JC: I could have made a traditional documentary of the story using photographs, home movies, family interviews, and archival footage. But I don't believe it would have been as personal, powerful, or unique a piece, because animation is so integral a part of my life. I think with any hand-drawn, frame-by-frame animation there is a visceral connection between head, heart, and hand.

I think you can go further in animation in some ways than you can in live-action: psychologically, symbolically, emotionally. The Hubleys [John and Faith] were great models for me. In their film *Everybody Rides the Carousel*, the child growing up has anger growing inside, and the anger becomes a lion coming out of the child's mouth. What a great image! I would suggest many ideas (which weren't used) to the producers of the child abuse film, for example how a child might become a tornado of anger, or become a bowling ball and knock over the pins of people who were abusing them.

FIG 3.11 Idea sketches for fistfight and gunshot scene (Scene 2).

Also, before I worked on *You Don't Have to Die* and *Break the Silence*, I worked on a film about teen suicide; it was child friendly. The medium of animation is child-friendly. I also worked on the feature animation in *The World According to Garp*, and that was taking drawings that the baby Garp had drawn and bringing them to life. Again, that was childlike in that it's crayon quality; it was naive, innocent, and that was something I was able to use in some of these other documentaries. The child is not turned off or frightened by the animation, but instead is drawn in.

FIG 3.12 Layout for Scene 207: the turtle "father" bites his younger son's finger, which affects his wife and three children.

FIG 3.13 Red gouache painted animation drawing (#21) of Scene 207: the turtle "father" bites his younger son's finger, which affects his wife and three children.

JK: *How did your actors prepare for* The Moon and the Son, *and what did you communicate to them about what you were trying to accomplish with the film?*

JC: I happened to have two great actors who required very little preparation. Eli Wallach loves what he does so much. I met with him after he agreed to do it. He came over to my apartment, and as he was walking across my living

room, the script was on the table, and as he was sitting down he was starting to read it in the accented voice of the character. He "became" my father. Just amazing! I recorded with him for the first session. He and John Turturro never worked together; they were two years apart, but there was a connection. I read with Eli: there were big microphones in front of us, and I swore it was my father in the room. He just had . . . he had everything I wanted. Occasionally, I would say, "Could you whisper that line?" or "Could you try it this way or that way?" But when I saw him come into the studio, he was like a young guy, bustling with energy; he couldn't wait to get started. That's his approach to acting, and Turturro is the same way.

We pursued Turturro for quite a while, maybe six months or so. He was very busy with his own film; he had many obligations, but he had read the script and wanted to do it. So we said we'll stay on you and we'll keep after you, and he said "fine." He was very accommodating. Finally, we were able to get him into the studio. He came in with a cup of coffee in his hand, he put on the earphones—he was listening to Eli in the earphones, watching the film as it was running, and he did his lines. One take! In an hour he was gone. He was just great. He posed for pictures and Eli posed for pictures, but they never worked together. A year or so later, we went back to Eli and brought him into the studio again, and you know . . . he was a little bit older then, and he was very sweet and friendly, as always. I said, "Eli, I really need you to have a lot of energy in this one," and he said, "Don't worry." So of course, the tape started and it was just amazing—the voice was there! Actors are great; if you get really good actors, they're worth everything.

FIG 3.14 Character model for mother, dated December 30, 2000.

JK: *What was the hardest part about making* The Moon and the Son?

JC: Wondering at certain points in the creative process how deeply I should explore the emotional content of my life, or if I had gone too far or not far enough.

FIG 3.14A Visual explorations for how father met mother and fell in love; images metamorphosis into birds, color ideas.

JK: *Did you make an animatic before going into production? If so, can you describe the process?*

JC: Images are shot or scanned in from the storyboard, then a "scratch" or preliminary soundtrack (in this case, a voiceover) is added and the drawings are timed so that they change sequentially according to audio cues. The purpose of making an animatic is to view the whole film in sequence and in real time in order to assess the story structure and character development; and to show the work-in-progress to potential funders.

JK: *Did you use any digital technology in making this project? How do you feel about digital technology in terms of your own personal work?*

JC: I've certainly used it in terms of postproduction. The editor and the composer used computer technologies: Final Cut and Protégé, respectively. Three brief scenes were scanned and transferred to the editor electronically; the rest was shot on 35mm by a frame-by-frame camera. Music for *The Moon and the Son* was composed on computers. But since then—on other projects—I've used scanning and After Effects.

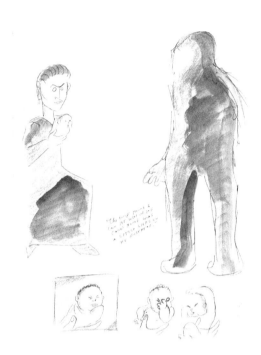

FIG 3.14B Hazelton, Pennsylvania, coal-mining sequence story idea sketches. "The only thing I can see when he came home was a little light on his forehead." Drawing dated July 28, 1999.

FIG 3.14C A character model drawing: abstractions representing the "family": (l to r) mother (green amorphous shape), younger son (yellow oval), older son (pink square), father (lightning). Dated August 3, 1999.

FIG 3.15 Conceptual sketch dated June 30, 1999: Son "dances about (his) mother presenting stolen goods," a scene later added to the final storyboard.

FIG 3.16 Three sequential idea sketches for the "family" in the abstract section of the film, dated August 3, 1999.

JK: *How long did it take you to make this film?*

JC: When I finished it in 2004, I joked to interviewers that *The Moon and the Son: An Imagined Conversation* took me 61 years to make. In reality, the production took about four years because I didn't work on it fulltime. I was also heading the animation program at NYU's Tisch School of the Arts Kanbar Film Department, teaching, writing books/articles/reviews, traveling, and lecturing.

FIG 3.17 An early storyboard of the dinner table sequence, a version (never used) with the family depicted as various animals and an invasion of religious cousins, including four nuns.

FIG 3.18 An early storyboard of the dinner table sequence, a version (never used) with the family depicted as various animals and an invasion of religious cousins, including four nuns.

Though self-directed animation is a form of filmmaking used by many animators, it is not often used to tell a personal story. In general, audiences are used to viewing animated films as entertaining diversions from the sometimes harsh realities of life. *The Moon and the Son: An Imagined Conversation*, on the other hand, immediately brings the viewer into Canemaker's real-world experiences and compels us to understand the distress and reality of what it was like to have grown up with a father who had spent time in prison. Canemaker uses a very popular medium to tell a very private story.

FIG 3.19 The first idea doodle for the film that became *The Moon and the Son* in 2004, "based on a dream 12/20/98."

JK: *How did you first become involved with animation?*

JC: I always loved cartoons and always drew as a kid. In 1955, when I was twelve, I made a short animated film—ironically on the history of animation—based on a Disneyland TV show I saw.

JK: *How do you direct the person shooting your drawings?*

JC: I use exposure sheets to instruct or direct the cameraperson on how to shoot the artwork, how many frames, what kind of camera moves, in-camera cross-dissolves, fades, etc. I do have a light table at home, so I do the animation here.

FIG 3.20 One of two exposure sheets (directions for the cameraperson regarding the number of 35mm film frame exposures per drawing for Scene 2 "fistfight/gunshot."

JK: *Did you use any special techniques while at the animation stand?*

JC: For one scene, we "pixilated" my hands changing the cels under the camera rostrum. That is, the live-action was shot frame-by-frame, so it looks speeded up.

JK: *Do you prefer to work on paper or on cels?*

JC: For my past films, including *The Moon and the Son*, it depended on what was needed for a scene or sequence; sometimes a combination of paper and cels. For films going forward, there will be scanning and coloring on the computer.

FIG 3.21 Final version of animation drawing #50 for Scene 2 "fistfight/gunshot." Drawing painted in black and white gouache on textured gray pastel paper.

In the world of independent animation production, it is the director's unique artistic vision that determines what is known as the "look development" stage of the project and decides whether currently popular techniques such as rotoscoping, CG animation, stop-motion, vector-based animation, and/or motion capture will be used in the production process. How will the background environments be designed? What do the characters look like? Will the props be rendered to look more photo-real? In Canemaker's very personal film, a more tactile, hand-drawn approach was taken, allowing the viewer to connect with and respond to his unique experiences and feelings.

FIG 3.21A The first of five layouts for Scene 2 "fistfight/gunshot."

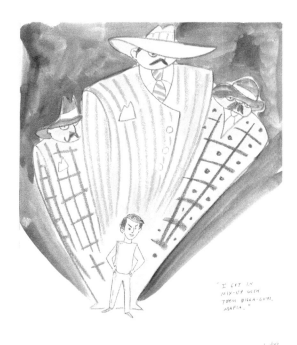

FIG 3.22 Conceptual drawing of young man backed by Mafia. Matching voice-over description: "I get in mix-up with them bigga-guys. Mafia." Sketch dated July 29, 1999.

FIG 3.23 Idea sketches for scenes in courtroom testimony and police arrest sequences, dated August 5, 1999.

JK: *How would you categorize this film? Is it an animated documentary?*

JC: I leave it to others to slot it, but I wouldn't object to the term "animated documentary."

JK: *What should animators and documentarians learn from your experience in making this film?*

FIG 3.23A Idea sketches for sequence about how a 1908 earthquake in southern Italy affected an immigrant couple and their baby living in Hazelton, Pennsylvania, and led to their return to Calabria.

JC: That each form of filmmaking—live action and animation—needs to be respected for its unique properties. Each technique requires a somewhat different approach, I believe. If one is lucky, they strengthen and enhance each other and can offer audiences a keener insight into story and character than they otherwise would alone.

JK: *The natural imperfection of the hand-drawn line adds an immediate intimacy to your film. Did you go through a sort of look development process when you first started this project? Though there is a tiny amount of rotoscoping, did you consider other techniques to tell your story (cut-out animation, CG, etc.)?*

JC: I started with research materials—newspaper reports, transcripts from my father's court trial, family photos, a transcript of an taped interview I had with my father a couple of years before he died, among other inspirational sources, including a few dreams. Based on that material, I began making many concept sketches, idea drawings, paintings and doodles in different media, i.e., pencil, inks, pastels, watercolors, gouache, etc. By the end of my one-month residency in Bellagio, working every day, I had a first draft of the storyboard and a script. Refinements and development of the narrative took place when I returned to New York, with discussions with the film's producer Peggy Stern and others, but the basic structure and imagery were there.

FIG 3.24 Conceptual sketches on one page for "jailbird" scene.

FIG 3.25 Rough sketches for images and dialogue for "jailbird" scene.

JK: *What advice would you give to aspiring animators? What are their greatest challenges?*

JC: Following through each day and sticking to the task in order to whittle down the mountain of work that any type of animation requires.

FIG 3.26 Preliminary drawings for visualizing Mafia tossing lighted match onto house being juggled by financially struggling father. Drawing dated May 16, 1999.

Being a Jack-of- All-Creative-Trades

Interview

JK: *How have you supported yourself as an independent animator?*

JC: I've had a very lucky career. I came to New York when I was 18, to be an actor. I was an actor; I did mostly TV commercials for about three years. I was in the army . . . I made a lot of money making these commercials, because you get residuals each time they're aired.

JK: *What commercials were you in?*

JC: I did 15 for the American Dairy Association. I was the Armour Hot Dog man. I did Benson and Hedges cigarettes when you could advertise those on TV. I was in a Foster Grant sunglasses commercial. I did a lot of stuff—I'd get pies in the face, they'd fly me through the air . . . I was the stunt-double for Dick Van Dyke in two of his worst movies: something called *Never a Dull Moment* (1968) and *Some Kind of A Nut* (1969). His recent autobiography mentions both movies. I did a kids' show on television. I did off-Broadway. I was performing, and I made enough money from the GI Bill and from my TV commercials to put myself through Marymount Manhattan College from 1971 to 1974. I was going fulltime to college, and that's where my interest in animation—which I did when I was a kid in Elmira—came back. A nun who had taught me said, "Why don't you go out to Disney, and I'll give you six credits if you write a paper on Disney animation." So I wrote a letter to the Disney Archives, and they said "Yes, come on out." I went out the summer of 1973, met the Nine Old Men,[2] saw many films and original artwork at the studio, came back to New York with all this information—in fact, I used much of this information 20 years later in my "Nine Old Men" book—I wrote the paper, and from that I started to produce and direct animated films. Then I became an animation historian and a teacher, because I started to do more research. I went on to graduate school at NYU, and in the meantime I kept making films—I was an independent animator; I did all of these things at the same time. When I graduated from NYU after two years, I had a contract with my first book company, and I've since written ten books and over a hundred essays, periodical articles, etc. So I wasn't just an independent animator. The point is, you have to have other things to support yourself as an indie. When I first came to New York, I was a doorman at Radio City Music Hall and a singing waiter in Greenwich Village. I was going to acting school at the same time and place as Liza Minnelli. It was a very strange career path; I can't recommend it because everyone has their own experiences. I think you have to be realistic, and you have to find other ways to support yourself.

[2] The members of the Nine Old Men were Les Clark, Marc Davis, Ollie Johnston, Milt Kahl, Ward Kimball, Eric Larson, John Lounsbery, Wolfgang Reitherman, and Frank Thomas.

I have my own production company; when I got *The World According to Garp* I incorporated. So I've done commercial work, sponsored work, and then I do my independent films, which are in the permanent collection of the Museum of Modern Art, and I won an Oscar . . . so everything sort of happened, almost all at the same time.

The Art of Funding the Arts

Interview

JK: *Who are some of the biggest supporters of independent animation, and what are some of the broadcast outlets who have consistently supported it?*

FIG 3.27 Idea story sketches for possible use in an Italian wine-making sequence with metamorphoses of trees into wine barrels (never used in final film), dated July 28, 1999.

JC: PBS has been a consistent supporter. The AFI was . . . and may still be. I've been granted a residency twice at The Bellagio Center in Italy through the Rockefeller Foundation. I've worked on documentaries with animation for CBS—nothing consistent. I'm afraid I'm not very helpful in terms of giving a career path; you just have to get out there and try.

JK: *Yes, finding your own path. Would you still produce commercial work now if it came to you?*

JC: If it came to me, yes. Something did come to me, and I was too busy to do it. I'd like to do the things I want to do; and that is, I'd like to continue to write my books, and I like teaching.

JK: *Do you write grants?*

JC: My producer, Peggy Stern, does. She's the one who got the money and suggested I go to HBO for our final funding for *The Moon and the Son*, which we did. First, I won a NYSCA [New York State Council on the Arts] grant—it was about $15,000—and the rest of the budget was supplied by HBO. I'd worked for Sheila Nevins [president of HBO Documentary Films] on *You Don't Have to Die*, so she knew my work.

JK: *When applying for funding, what makes for a successful proposal package, both in terms of sample reel and proposal?*

JC: For *The Moon and the Son*, we had a very crude animatic; I'm really surprised it got funded! The people who watch films—the NYSCA people and Sheila Nevins—they've seen so many films, they could see the potential. Sheila encouraged us and so . . . we got money to do it. On *The World According to Garp*, a Warner Bros. feature, director George Roy Hill had seen my independent work—another reason why you should get your work out there, and it's easier to do now than ever before.

JK: *Meaning YouTube, or . . . ?*

JC: YouTube or Vimeo—all you have to do now is transfer your film to a disk—we used to have to put in on 16mm and ship it off. It was expensive.

FIG 3.28 Idea sketches on one page suggesting imagery in "phone call sequence."

With the Internet, there's no reason people can't get their stuff out there and become "famous." Jobs come from everywhere.

Teaching at NYU

Interview

JK: *Can you talk more about what you're teaching?*

JC: At NYU I teach two courses, because I'm an administrator as well. I'm the Executive Director of the Animation Program at the Kanbar Institute of Film and Television, which is part of Tisch. I teach Storyboarding and Intermediate Animation Production in one semester, and in the other semester I teach Action Analysis II, which is about putting emotion into the animation of a thinking character. In our curriculum, we have courses in CG and stop-motion; we have two drawing courses in anatomy and drawing the figure; we have 2D and 3D digital animation techniques. The film department has over 1,000 students—we're not a major, but the students can focus on animation. I'd say we have about 50 to 75 hard-core animation students; and more who are interested in animation are coming in all the time. We're starting a new class this fall (2011) in Visual Effects and Compositing that's filled up so quickly it already requires a second section.

FIG 3.29 Rough thumbnails working out ideas for the car crash and jail sequence.

JK: *What is the most important thing you're trying to get across to your students?*

JC: Remember Jules Engel?

JK: *Of course! He was my mentor at CalArts.*

JC: He was a good friend of mine and an inspiration in terms of teaching. I said, "What's your secret, Jules?" And he said, "It's not what I give to my students, it's what I don't take away."

I want my students to acquire the powers they need to express themselves as artists. I want them to learn through the production courses and through the craft courses what an art form animation is. I want them to learn first-hand what you need in terms of organization and energy and never giving up and coming back the next day with renewed energy. I want them to try things out on people and learn from that experience. I want them to express who they are in animation, because we're all creative and everyone has something unique to say. They shouldn't imitate somebody else, but they should use the time they have in school to discover their potential as communicators and find out how they can make films that affect people emotionally. I want them to discover themselves, because once their talents are discovered by other people, they may work for studios who will want to use them for one specific thing; and that will be "it" for them. I hope they always keep their love of animation—if working in the studio is their day job, they should try to find the time and energy to make their own films. Animation is like poetry, it's like sculpture and painting, it's acting, it's writing. It's all of these things combined. It's an art form. It's an expression of you as a human being.

Current Projects

Interview

JK: *Are you working on any new films?*

JC: Yes, I'm working on a film that's based on an American short story. I have done storyboards for it. I did get another grant from the Rockefeller Foundation, so I went to Italy in 2009. I can't say too much about the project yet because I'm trying to make sure that I've secured all the rights. I do have an animatic for it and hopefully my producer, Peggy Stern, will be getting funding, and I'll be able to move forward. My new book will also take me a year to do . . .

JK: *I can well understand that! What are some of the books you've worked on in the past, and what book are you currently working on?*

JC: I wrote a book on Tex Avery, another on Winsor McCay, on Felix the Cat, and one called *Walt Disney's Nine Old Men and the Art of Animation*; which was nine biographies in one volume. I had met eight of the nine in 1973, when I first went out to the Disney Studios for a college paper, and I became very good friends with four of them: Frank Thomas, Ollie Johnston, Ward Kimball, and Marc Davis. When it became possible to do this book, I flew out to California and interviewed the four of them. I interviewed each one for a day, and it was a wonderful experience. I think I captured something about each of their personalities; I found out information that hadn't been published before about each of them. I try to do that with all my writings.

Before the Animation Begins is about the conceptual artists who worked at Disney—a lot of whom people had never heard of—yet I had met some of them, like Bianca Majolie, who was the first woman story artist at Disney. I visited with their families; Mary Blair's son was very helpful for her chapter, and I ended up writing an entire book about her as well [*The Art and Flair of Mary Blair*].

I'm currently working on a biography of a man named Herman Schultheis who worked at the Disney Studios from 1939 to 1941. He was a special effects expert in the Special Process Lab, as they called it. He was a photographer and a technician who went around and took photographs of all the special effects in *Fantasia*, *Pinocchio*, *Dumbo*, *Bambi*, and *The Reluctant Dragon*, and he created scrapbooks that reveal the secrets of special effects in these classic Disney films. The Disney family now owns all the scrapbooks, and they asked me if I would do a book about who Herman Schultheis was and his discoveries. There had been very little information, but we're now finding out a lot about him. He created these wonderful documents that show, for the first time, how the multiplane camera effects were done for that wonderful shot in *Pinocchio* in which the camera goes through the village and the kids go to school; it's an amazingly complex shot. He shows how the delicate snowflakes were done in *Fantasia*, which turns out to have been a very mechanical process. I'm very excited about researching and writing this book.

JK: *How would you compare what Disney did back then to what's being done today? Is one style "better" than the other?*

JC: I think that the Principles of Animation that they codified at the Disney Studio in the 1930s are essential, and continue to be used today in every form of animation, particularly in the CG work that Pixar is doing. Principles like timing, and squash and stretch, and anticipation and follow-through—all those principles that were developed from hand-drawn animation remain important and essential today. In fact, drawing skill is still useful for CG animators to train the eye to observe action and create strong storytelling character poses. At NYU, we have 17 different courses in animation per semester—traditional, hand-drawn animation as well as CG animation. The experience of seeing your work on the screen, whether it's CG or hand-drawn or puppets, is the best way to learn animation and analyze it frame-by-frame and correct it; to learn if you're communicating with the audience. Staging is another one of the Principles of Animation. It can be the way a character is posed; it can be color—how is color used? How is the character positioned on the screen? All of these things have to do with trying to communicate clearly to the audience. These are all basic principles going back to pantomime, going back to theater. I think every animator should take acting lessons or dance lessons. Get out there and try to communicate in that way, and then you'll feel how it should happen in your own body, and then you'll be able to transfer that into your own animation.

Revealing the Truth, One Frame at a Time

Contemporary animation production practices allow for the use of numerous software packages that virtually eliminate the use of camera, paper, pencil, and/or cels. Though this is the direction in which most film production has gone, on some level it can also reduce the connection the filmmaker has with the act of making and editing the film. It is no longer necessary to create animated films by hand, using drawings shot with an animation camera; however, Canemaker chose to use these techniques for his Academy Award-winning project. In a sense, the production decisions and processes become embedded as part of the story told by the animator, who by nature must cultivate an enormous sense of patience before undertaking this kind of filmmaking. Part of the pleasure in viewing this film is in seeing the charm in the imperfect splashes of paint and "boiling" pencil lines used to bring the audience into Canemaker's world. It is as if the contrast between the very real pain conveyed in the script and the hand-drawn, very intuitive techniques chosen to produce *The Moon and the Son: An Imagined Conversation* serve to heighten the intensity in Canemaker's story. There is a vigorous connection between the artist's head and heart; technology never gets in the way.

Films such as Ross McElwee's *Time Indefinite*, Nathaniel Kahn's *My Architect*, and Lucia Small's *My Father, the Genuis* are but a few examples of documentaries that explore father-child relationships. Canemaker's autobiographical *The Moon and the Son* explores a similar family dynamic, but with the understanding of using animation as a means of personal expression. His film speaks from the heart and resonates so powerfully because of his fearlessness in revealing the details of such an intimate and at times painful personal history. Canemaker's films are timeless, and it is small wonder that they are part of the Museum of Modern Art's permanent collection.

French Canada's Rising Star: Marie-Josée Saint-Pierre

Biography

Born in Murdochville, Quebec, Marie-Josée Saint-Pierre is a French Canadian filmmaker based in Montreal, Canada. Saint-Pierre obtained a BFA Honors in film animation and an MFA in film production from the Mel Hoppenheim School of Cinema at Concordia University.

Saint-Pierre's animated documentary work shows new approaches in nonfiction storytelling, by blurring the lines between documentary and drama and incorporating a mixed media approach. The award-winning director and film animator has directed several short animated and documentary films, including *Post-Partum*, an exploration of abandonment and postpartum depression; *Passages*, an autobiographical story about the birth of the filmmaker's first child; *The Sapporo Project*, a unique animated glimpse into the world of acclaimed Japanese calligrapher Gazanbou Higuchi; and *McLaren's Negatives*, the 2007

FIG 4.1 Marie-Josée Saint-Pierre.

JUTRA award winner for best animated film about celebrated filmmaker Norman McLaren. She is also the co-producer of *The Delian Mode*, directed by Kara Blake. Saint-Pierre is currently directing two mid-length animated documentary films: *Femelles*, an exploration of Quebec women going through motherhood, as well as *Jutra*, a portrait of the legendary Quebec filmmaker Claude Jutra.

Marie-Josée Saint-Pierre founded MJSTP Films Inc., an animation and documentary production company, in 2004. Her film work has been screened at over 150 prestigious festivals around the world while receiving many awards. She has lectured on the art of animated documentary filmmaking in Europe, Asia, and Canada. She has also been a jury member for the Canada Arts Council, the Ottawa International Animation Festival, and the London International Film Festival. In 2008, she was selected as the international artist in residency for the S-AIR Inter-cross Creative Center in Sapporo, Japan where she created the film The Sapporo Project.

She currently lives in Montreal where she spends her time making films and raising her three daughters Fiona, Chloé, and Emma.

Homage to the Genius of Norman McLaren

Norman McLaren was an Oscar-winning animator and director. Born in Scotland in 1914, McLaren moved to Montreal, Canada at the invitation of John Grierson, the founder of the National Film Board of Canada and one of the fathers of documentary filmmaking. McLaren's groundbreaking work included experimenting with animation techniques such as painting and scratching images and sound directly onto film stock. McLaren started the animation program at the National Film Board of Canada and is best known for directing his Oscar-winning film, *Neighbours*. This 1952 production contained McLaren's strong antiwar message and used an animation technique known as *pixilation* and invented by McLaren. This technique involves the frame-by-frame animation of actors, who must hold their poses while the camera shoots a set amount of frames, resulting in a very original and unique look when played back at 24 frames per second. Nowadays, pixilation is a very common technique used in music videos, commercials, and feature films.

Neighbours begins with two men sitting in front of their respective houses, each reading the newspaper. One newspaper headline reads "War Certain if no Peace," while the other headline reads "Peace Certain if no War." Inspired by the Korean War, *Neighbours* vehemently condemns violence and exemplifies McLaren's strong concern for human welfare, values, and dignity.

McLaren's Negatives is Saint-Pierre's award-winning visual essay on Norman McLaren and pays tribute to his genius and innovative creations. The experimental nature of Saint-Pierre's films is, in part, a result of her passion and admiration of McLaren's work.

FIG 4.1A

Interview

Judith Kriger: *How did you first get involved with animation?*

Marie-Josée Saint-Pierre: Here in Quebec, after high school, there are public postsecondary educational institutions known as CEGEP [collège d'enseignement général et professionnel], which prepare you to go to university. I chose to specialize in advertising and had access to high-end CG software called Softimage, and I did a little animation and absolutely loved it. I think I was 18 when I did my first animation.

JK: *Who or what inspires you?*

MJSP: I really like Norman McLaren, of course. I remember when I was doing my BFA, many of the students come to the realization that animation is hard to do; how time-consuming it is, and I wasn't so sure that I would be a film animator because everything is so complicated. I remember seeing McLaren's work, and I fell in love with what he made, and that's what inspired

FIG 4.2 McLaren's Negatives.
©MJSTP Films Inc. 2006.

FIG 4.3 McLaren's Negatives.
©MJSTP Films Inc. 2006.

me to continue to stay in school; I had been thinking about dropping out because I had thought it was too much work to make animation. For me, he's a really big inspiration; for all the techniques he came up with and the stories he told, he's really my favorite animator of all time.

FIG 4.4 McLaren's Negatives.
©MJSTP Films Inc. 2006.

FIG 4.5 McLaren's Negatives.
©MJSTP Films Inc. 2006.

JK: *It's so perfect that you paid homage to him.*

MJSP: Yes. It's so funny because this film is about 10 minutes in length and it took me 5 years to make—from the original idea to the finished pro duct—not because I'm retarded. <laughs> When I started making this film, no one knew me, no one had heard of me, and I wanted to make a film about this national treasure. So it was really hard to get the funding, to convince people to give me archive rights and photos and things like that. I think subconsciously, I wanted to make a film about him because he's the one who kept me involved with animation.

JK: *Do you have a signature style?*

MJSP: Some people have said that my signature style is rotoscoped animation. But . . . I would say, the more films I make, the more my process entails mixing media together, and it's a sort of hybrid of different techniques. I think this is very challenging, because it can easily look really bad. If you have different genres or techniques, it's hard to get them to look good when they're put together. The *Jutra* film, the next film I'll be making, will mix animation, archives, and live HD footage. I like to mix as many different kinds of media as I can, but . . . it has to look good! It's not easy to do. The films that I make are both mixed media and mixed genre. I leave it to the viewer to decide whether it's animation or a documentary and how to categorize my work.

JK: *How does your work show new approaches to nonfiction storytelling?*

MJSP: I think the interrelationship between the image and what is being said on camera, fictionalized images with documentary sound. For example, in the film I'm working on now, *Femelles*, I'm getting to a point more and more where the images are much more surreal. There's more of a dichotomy between what you see and what you hear.

FIG 4.6 McLaren's Negatives. ©MJSTP Films Inc. 2006.

FIG 4.7 McLaren's Negatives. ©MJSTP Films Inc. 2006.

FIG 4.8 McLaren's Negatives.
©MJSTP Films Inc. 2006.

FIG 4.9 McLaren's Negatives.
©MJSTP Films Inc. 2006.

FIG 4.10 McLaren's Negatives.
©MJSTP Films Inc. 2006.

JK: *What attracted you to documentaries, and are there documentary film-makers who inspire you?*

MJSP: After I did my Bachelor's in Film Animation, I did my Master's in Film Production. In my Master's program I did a documentary essay on post-partum depression, and that was my first encounter with documentary. The first film I did was *McLaren's Negatives*. I didn't want to do an "animated" documentary; I didn't know I had made an animated documentary until people told me so. I think it's an accident in a way, because I was making a film about an animator, so I was kind of documenting an animator, and it just happened like this. The film was released in 2006. Back then, animated documentary was really an oxymoron; documentary was supposed to represent reality, and animation is nothing like that, so people were quite . . . not "offended" . . . but they didn't really believe in the genre. I find that as more years go by, more people are more open to it, and more people want to learn about it.

JK: *Why do you think that is?*

MJSP: I think the genres of film have become more stretched. The definition of what films are—you can really stretch the boundaries. In 2006, people said it can't be a documentary because it's animated. But now people can recognize that documentary can be a mix of genres. When Michael Moore won the Palme d'Or at Cannes for *Fahrenheit 911*—it's *his* vision of what American society is, so one can recognize that documentary is really the vision of the filmmaker.

JK: *The film-going public's perception of documentary is more open-minded than it used to be.*

MJSP: Yes, I think before, the audience felt that it had to document reality.

JK: *You mentioned Michael Moore, are there other people who inspire you?*

MJSP: I like a lot of films made by the National Film Board of Canada. Their animation, in particular, is very strong. They have different styles and different animators. I also like more experimental films, like those made by Stan Brakhage. They have absolutely nothing to do with my current work, but I like what he does. I like abstract painting a lot; in particular, I like a painter from Quebec named Jean-Paul Riopelle. I also really like the paintings of The Group of Seven, who were a group of Canadian landscape painters from the 1920s.

JK: *Would you describe yourself as an experimental filmmaker?*

MJSP: No, because then I wouldn't get any funding to make my films! <laughs> I don't think I'm mainstream . . . I think there's an experimentation in the way I make my films . . . would say yes, but I would never write that in a grant application, or when I'm applying for funding for TV broadcast.

FIG 4.10A

Passages

This film tells the autobiographical story of the director's experience giving birth to her first child, Fiona. What should have been a joyous experience turned into a near catastrophic nightmare due to lack of adequate medical support. *Passages* uses the animated documentary form to show Fiona fighting for survival and leaves Saint-Pierre questioning why she did not receive better care.

FIG 4.11 Passages.
©MJSTP Films Inc. 2008.

UVEAU-NÉ N° dossier :						
APGAR	0	1	2	1min.	5 min.	10 min.
Battements cardiaques	Absents	Moins de 100	Plus de 100	2	2	2
Efforts respiratoires	Absents	Lents irréguliers	Bons pleurs	0	0	1
Tonus musculaire	Flasque	Flexion des extrémités	Mouvements actifs	0	1	1
Réflexes à la stimulation	Absents	Grimace	Pleurs avec force	0	0	1
Coloration des téguments	Bleue pâle	Corps rose extrémités bleues	Entièrement rose	0	1	1
			Total	2	4	6

Signature du médecin ayant fait l'évaluation Année Mois Jour

Date

non ☐

N DE LA MÈRE

FIG 4.12 Passages.
©MJSTP Films Inc. 2008.

Interview

JK: *What was the reaction among your peers and among mainstream viewers to your film* Passages?

MJSP: I've been to screenings of this film where women sitting behind me in the audience were crying. I think for some men this film might be difficult, because it's really about childbirth and it's not an easy story. I think it touches women more. It's not really a mainstream animated film, nor is it a film for kids; it's a film for adults. I think there's been a bit of a difficulty for this film to find an audience because it's not mainstream. But I don't want to do mainstream animation; I want to make the films that I want to make. I have something to say that is particular to me, and I think it resonates with my audiences. I have a particular "niche," and that's the audience for whom I make my films.

FIG 4.13 Passages.
©MJSTP Films Inc. 2008.

FIG 4.14 Passages.
©MJSTP Films Inc. 2008.

FIG 4.15 Passages.
©MJSTP Films Inc. 2008.

JK: *It's obviously a very personal film, and it's very upsetting to watch. You have a very stark look to that film, because what you're describing—you were between life and death. It's very black and white; there's a high contrast. Do you view animation as a means of self-expression?*

MJSP: Absolutely. I think I have two branches in my filmmaking styles. One is to make portraits of artists whom I really like, and the other side is to make more personal films. It's important for me, as a woman, to make personal films about women's issues. After what happened when my first daughter was born, there wasn't anything I could do; my only recourse was to make this film. It was really hard for me to make this film because I had wanted to make it about the beauty of motherhood, but that is not what had happened. I was pretty angry when I made that film; of course I was. I think it was

vengeance, on a certain level. I'm happy I made it. I think if I hadn't made this film, the trauma would have been too great for me. It was cathartic; I was able to get out some of the emotion.

FIG 4.16 Passages.
©MJSTP Films Inc. 2008.

FIG 4.17 Passages.
©MJSTP Films Inc. 2008.

FIG 4.18 Passages.
©MJSTP Films Inc. 2008.

FIG 4.19 Passages.
©MJSTP Films Inc. 2008.

FIG 4.20 Passages.
©MJSTP Films Inc. 2008.

JK: *Is your daughter OK?*

MJSP: Yes . . . though, there may be an issue with language . . . We'll know more when she starts school and she starts writing. You know, in Africa one out of ten women dies in childbirth. We're in Canada; we're not in a third-world country! I haven't been to many of the *Passages* screenings, but when I have gone, there are always women who come up to me afterwards and tell me their stories of what happened to them when they were giving birth. When you're open about it, people will respond. The expectation is that giving birth is always rosy; people don't always want to talk about it when it isn't.

I think it's important in animated documentaries to use animation in a way that will give the audience the information in a more interesting way, maybe to make them think more. It's important for the director to know why animation is used. Why not just use a camera and microphone as in "normal" documentaries? There must be a point to using animation in documentary films.

FIG 4.21 Passages.
©MJSTP Films Inc. 2008.

FIG 4.22 Passages.
©MJSTP Films Inc. 2008.

FIG 4.23 Passages.
©MJSTP Films Inc. 2008.

FIG 4.24 Passages.
©MJSTP Films Inc. 2008.

Femelles

Femelles is an animated documentary exploring the range of experience of motherhood. By interviewing Gen X mothers from Quebec, Saint-Pierre presents a more realistic, less glamorized picture of childbirth and mother-hood that is at times funny, touching, and sad. *Femelles* will be released in 2012. It documents the reality of a new generation of young mothers and validates oftentimes unspoken experiences of motherhood.

FIG 4.25 Femelles.
©MJSTP Films Inc. 2012.

JK: *Are you set up at home? Do you have to rent any equipment?*

MJSP: Yes, everything is here: I have three computers, two laptops, and a lot of hard drives. Sometimes the people who work for me work here, and sometimes we FTP the work back and forth. For rotoscoping, we use Toon Boom, After Effects, and Final Cut Pro, and we draw it using graphics tablets.

FIG 4.26 Femelles.
©MJSTP Films Inc. 2012.

For reference, we use found footage on YouTube. If this were 20 years ago, we couldn't make the films we're now making, because we really use the Web for our research. We save a lot of time by finding footage with the particular movements that we need. The one we're making now is 35-40 minutes—to animate that in a year and a half would be impossible, absolutely impossible.

FIG 4.26A

This is the process we're using for the films we make now, like *Femelles*. For the ones we did before, we shot here in my house with friends and a lo-tech camera, my own furniture. In *McLaren's Negatives*, we filmed my friends, my furniture, and in *Passages*, it's me and my husband. It's very low-budget. The way we're now doing it with *Femelles*—it's cheaper and a faster way of doing it than shooting it ourselves.

FIG 4.27 Femelles.
©MJSTP Films Inc. 2012.

FIG 4.28 Femelles.
©MJSTP Films Inc. 2012.

FIG 4.29 Femelles.
©MJSTP Films Inc. 2012.

FIG 4.30 Femelles.
©MJSTP Films Inc. 2012.

FIG 4.31 Femelles.
©MJSTP Films Inc. 2012.

FIG 4.32 Femelles.
©MJSTP Films Inc. 2012.

JK: *Are you downloading the footage from YouTube?*

MJSP: We don't download it. Actually, what we do is find a sequence we like and grab a frame, move it a bit, grab another frame, etc. We in-between between the main images, and it's great because it resolves a lot of issues.

FIG 4.33 *Femelles.*
©*MJSTP Films Inc. 2012.*

FIG 4.34 *Femelles.*
©*MJSTP Films Inc. 2012.*

JK: *How does combining animation with documentary filmmaking make the film more effective, and how do the genres strengthen and enhance each other?*

MJSP: I think a good thing about animation is that you can represent things that you can't ordinarily represent in real life. You can go deeper in terms of what is being said and what is being shown than you can in live-action. Also,

as an independent filmmaker, you don't have a big budget to make films—I can just draw whatever is necessary. The only limitation for me is my imagination. From my point of view, it makes making documentaries more interesting if I can use animation, because I can treat the subject differently than if I only had video cameras to document my subject.

JK: *Treat the subject differently in what ways?*

MJSP: For example, the documentary I'm working on now, *Femelles*, is about different women who are talking about motherhood and maternity. It's about women in their 30s who've had a child. It addresses the topic of maternity—the parts people don't normally talk about. I've also interviewed social workers and nurses, and everyone talks about childbirth, postpartum,

FIG 4.37 Femelles.
©MJSTP Films Inc. 2012.

breastfeeding, everything surrounding maternity. I've done audio interviews with different women, and I think if I had done the interviews using a video camera, they wouldn't have been as comfortable telling me some of the things they told me. They're anonymous; no one can compromise them, so they really told me "secrets," and now I can use their secrets in the film and no one will recognize them. I can in any visual things that I see; I'm not making a documentary in the traditional way. People are more willing to share more personal things with you because they're anonymous.

I'm actually a little worried about this film. If I didn't have kids, I couldn't make this film. *Femelles* is about what it's like to have children and how society romanticizes motherhood. If you look at celebrities who have kids . . they're back in shape a week after giving birth, and it's almost as if their baby is an accessory, like having a new purse. I'm a little worried about this film, because it might come across as "discouraging" women from having children, because they'll see negative sides to it. I think some women who see this film will think that I'm complaining, but I'm making *Femelles* because I think that there's so much commercialization and marketing of babies. I mean, thousand-dollar strollers? It's so "trendy" now and fashionable to have a baby. But the reality is, when the baby wakes up 10 times during the night; from 1:00 A.M. to 6:00 A.M. . . . it's not pretty, and it's not about being fashionable. I'm making this film because I think it's important to talk about the issues regarding childhood that no one talks about. It'll be interesting to see what kind of reaction I get to this movie.

I have a sequence where you see a figure of a baby being shaken. Shaken Baby Syndrome really does exist. Some of the people who are working with me on this film are wondering if it's too shocking. I know it's shocking, but it does exist. I don't think I'm going too far, but it will be interesting to see how people react to the movie.

FIG 4.38 Femelles.
©MJSTP Films Inc. 2012.

FIG 4.39 Femelles.
©MJSTP Films Inc. 2012.

FIG 4.40 Femelles.
©MJSTP Films Inc. 2012.

JK: *Does the NFB (National Film Board of Canada) have a say in that? Will they tell you if it's going too far?*

MJSP: No, they have no say in the content, because I have a grant through their Filmmaker Assistance Program; it's for the postproduction of low-budget films, so they have absolutely no say in the content of this film. It's such a great privilege to have the liberty to make the film that I want to make. The only person who will censor me is me. I'm very grateful for the opportunity to make this film.

The other film I'm working on, *Jutra,* is a co-production with the NFB, so they will have a say in that one.

The Art of Funding the Arts

Interview

JK: *How have you supported yourself as an independent filmmaker?*

MJSP: I've supported myself by making my films.

JK: *You're able to live on that?*

MJSP: Yes. I have my own company. Here in Canada you can get tax credits, and you can get grants. You get tax credits when you employ someone—you get back twenty-five cents on the dollar. When the employment is finished, you receive money from the government. So that can help you to survive between productions.

JK: *Let's say you get a Canada Council Grant, is that enough to live on?*

MJSP: I try to get grants from different sources. In the best-case scenario, I get funding from the Canada Council, a grant from the Quebec Arts Council, one from SODEC [a cultural grant from Quebec], money from the National Film Board of Canada [NFB], and I will also get tax credits. From those combined sources, I will have a budget of approximately $250,000. With that, I'm able to make the film. I can hire people to help me, I can output everything, and I try to save a little bit so that I can survive between productions. I also have three kids below the age of five, and in Quebec there is also money for subsidizing children. I'm now also producing a film by animator Co Hoedeman and will be producing other people's films too.

I know that if I get out of producing and directing films and get a part-time job of some kind, my film production will end up not being my main occupation. There's a real danger of my stopping to make films, so I'd rather make less money and still make my films than get a part-time job and have my films fall into the background. You have to be passionate; if it's not a real passion you won't make the films.

Also, sometimes people ask me to do storyboards or animation for them; sometimes we work on corporate films. I don't actively seek that out, but if people have something particular in mind, I will say yes.

JK: *You've been funded quite successfully for your work. How would you advise someone who's new to this? What makes for a successful proposal package, both in terms of your sample reel and in terms of your proposal?*

MJSP: The first and most important thing is never to take "no" for an answer; never ever! If you apply for a grant and you don't get it, you need to call back and ask for the jury comments because very often—99% of the time—the jury comments are really intelligent, and they will help you to make the film better. So if you apply for a grant and don't get it, you try to get it again; that's the most important thing. I've been part of a jury, and sometimes proposals are too long or too elaborate. You have to make it simple; you have to make it clear and concise. The goal must be clear; don't try to write too much, because there are many applicants and you want your proposal to be attractive, simple, and to the point.

In terms of reels . . . I don't believe in reels; I believe in films. I've never done a demo reel of my work, ever.

JK: *Now you're more established, but when you first started, what did you show?*

MJSP: I showed my films in their entirety. They were . . . not that great, actually. With *McLaren's Negatives*, the first round of grants I applied for, everyone said no. The National Film Board of Canada rejected it, Canada Council rejected it. I called up and the comments were actually very constructive; I took them into consideration and I reapplied, and then I got my money. I think the film is better because of it.

FIG 4.41 McLaren's Negatives.
©MJSTP Films Inc. 2006.

JK: *What were some of the comments you got the first time?*

MJSP: It was a long time ago, but . . . they said that the documentary part was not quite strong enough, it was too "experimental," and my visuals were not

FIG 4.42 McLaren's Negatives.
©MJSTP Films Inc. 2006.

strong enough. They said I had a hard time explaining what I wanted to do, so the second time around, I had a couple of images with McLaren; I didn't have that in the first version. I demonstrated that I knew more about what I was going to do, and I had sections of the proposal that showed that I had done more research. It was much more intelligent and well put-together.

JK: *You've said it took you five years to make that film. As an animator, I can very much relate—can you describe some of your process for this film?*

FIG 4.43 McLaren's Negatives.
©MJSTP Films Inc. 2006.

MJSP: I started by creating the background; I hand-painted 16mm negative. I painted and dyed it and glued it onto 35mm leader. I was sort of in an experimental Brakhage/McLaren-esque influence. The background was the first thing, and then I worked on the photo research and the archival audio

FIG 4.44 McLaren's Negatives.
©MJSTP Films Inc. 2006.

FIG 4.45 McLaren's Negatives.
©MJSTP Films Inc. 2006.

interviews. When you listen to the film—you can't really tell—but I had different sources of interviews of McLaren, done by different people. I think I had over seven hours of interviews, cut down to 10 minutes. I had someone work on the audio to make it sound as if it was one continuous interview; to make it all sound the same.

JK: *What comes across to me in that film is your love of McLaren and of his work. Can you talk a little more about your process? Do you use storyboards or animatics?*

MJSP: I don't use storyboards or animatics. I'm an animator who doesn't really work with those things, and it's really awkward because everyone else

works like this. I can figure out in my head what my film will be before it's finished. Sometimes when people work for me they ask: "Why are we doing a particular thing this way?" And I won't necessarily know how to answer them, but in the end, it always comes together. I find that making films is a very organic process, and even the editing is part of the creation. I never lock myself in; it's always evolving, always changing until it's finished. It's heartbreaking to cut animated sequences because of how long they take to create, but it's better to do so than to later regret having left something in that doesn't work.

FIG 4.46 McLaren's Negatives.
©MJSIP Films Inc. 2006.

FIG 4.47 McLaren's Negatives.
©MJSIP Films Inc. 2006.

FIG 4.48 McLaren's Negatives.
©MJSTP Films Inc. 2006.

FIG 4.49 McLaren's Negatives.
©MJSTP Films Inc. 2006.

FIG 4.50 McLaren's Negatives.
©MJSTP Films Inc. 2006.

JK: *If you're not using storyboards, how do you direct your freelancers?*

MJSP: The film appears in my head as we work on it; I go with the flow. I don't know how to explain it exactly; all of my films have been made this way.

JK: *Well, it's obviously working!*

MJSP: Yes, the focus is on ideas. You never really know when a good idea is going to come to you. Some days I'll work for an hour and have many good ideas, and then three days later . . . nothing interesting comes to me. I find that when you're sitting and drawing, interesting ideas can come to you and you can "shape" them in interesting ways.

JK: *It's similar to sculpting, in a way. But when you apply for grants, don't you have to show them storyboards?*

MJSP: No, not really, because I make animated documentaries. So I can really emphasize the documentary side of my project, and include a couple of images showing what it will look like.

Current Projects

Frequently listed by the Toronto International Film Festival as the "best Canadian film ever made," *Mon Oncle Antoine* is a rural story set in the province of Quebec in the 1940s and directed by acclaimed Canadian director Claude Jutra. Born in Montreal, Jutra completed medical school by the age of 21 but had no interest in practicing medicine and instead devoted his time to the pursuit of filmmaking. Director and animator Norman McLaren invited Jutra to work with him at the National Film Board of Canada after seeing Jutra's award-winning film *Mouvement Perpétuel*, an avant-garde work made in 1949; eight years later they co-directed the animated short film *A Chairy Tale*.

In 1986, Jutra committed suicide at the age of 56. His body was later found in the St. Lawrence River with a note in his pocket reading "I Am Claude Jutra."

FIG 4.51 Jutra.
©MJSTP Films Inc. Work-in-Progress.

FIG 4.52 Jutra.
©MJSTP Films Inc. Work-in-Progress.

FIG 4.53 Jutra.
©MJSTP Films Inc. Work-in-Progress.

Interview

JK: *What attracted you to working on a documentary about Claude Jutra?*

MJSP: Claude Jutra has been named the best Canadian filmmaker of all time by many, many different people. I'm very interested in him—not only because I like his work—but also because I have a different theory about why he committed suicide. People think he killed himself because he had Alzheimer's disease and he couldn't live with the fact that he was sick. My theory, that I want to show in the film, is that he was a great filmmaker but he was in a situation where it was almost impossible for him to make his films; he had such a hard time funding his films. He was such an icon of Quebec sovereignty, and, at the end of his career, he had to go to English

Canada to make a living. People here felt he was a traitor and were critical of him when all he was trying to do was make a living. I think the fact that he had such a hard time making his films combined with the fact that his audience turned on him—to me, that's what drove him to commit suicide. I have a lot of interviews to document that, so that's why I want to make this film, but also to show what a hard time he had getting his films made. Also, a lot of people may not know who he was or be familiar with his films.

FIG 4.54 Jutra.
©MJSTP Films Inc. Work-in-Progress.

FIG 4.55 Jutra.
©MJSTP Films Inc. Work-in-Progress.

105

FIG 4.56 Jutra.
©MJSTP Films Inc. Work-in-Progress.

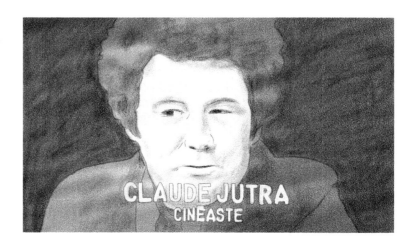

FIG 4.57 Jutra.
©MJSTP Films Inc. Work-in-Progress.

FIG 4.58 Jutra.
©MJSTP Films Inc. Work-in-Progress.

JK: *Is* Jutra *going to be entirely animated?*

MJSP: There will be less animation in this film, because I have interest in this project from broadcasters and they feel that the TV audience is not "ready" for a completely animated documentary film. Some of it will be animated, but there will be archival as well as live footage. Maybe in ten years this won't be an issue—as I was saying before, when I produced *McLaren's Negatives* in 2006, I was told back then that it can't be a documentary.

JK: *Maybe it just takes time for people to get used to viewing films like this.*

MJSP: I have a sense that broadcasters don't want to give the impression that they are funding a "film festival" kind of film, it's too "artsy." We're finishing up *Femelles* right now, and then we'll be continuing with *Jutra*. I have "too much work right now; it's great, I can't complain.

FIG 4.59 Jutra.
©MJSTP Films Inc. Work-in-Progress.

FIG 4.60 Jutra.
©MJSTP Films Inc. Work-in-Progress.

FIG 4.61 Jutra.
©MJSTP Films Inc. Work-in-Progress.

JK: *You wear many hats; you're a producer, director, and animator. Which do you enjoy most?*

MJSP: I find writing and researching very easy. But I'm used to doing everything. I edit the picture, the sound; I produce; I write the scripts; I do almost every part of my films. I hire people to do the things they can do better than I can—maybe I'm a control freak, maybe that's what it is, <laughs> but I like to touch all facets of filmmaking. If I had to choose . . . I think I would be really happy just writing and developing my ideas and researching. I have a strength for writing, maybe that's why I've been successful in funding my films. I would imagine it would be quite hard to fund films if you aren't able to write well.

FIG 4.62 Jutra.
©MJSTP Films Inc. Work-in-Progress.

FIG 4.63 Jutra.
©MJSTP Films Inc. Work-in-Progress.

FIG 4.64 Jutra.
©MJSTP Films Inc. Work-in-Progress.

FIG 4.65 Jutra.
©MJSTP Films Inc. Work-in-Progress.

FIG 4.66 Jutra.
©MJSTP Films Inc. Work-in-Progress.

FIG 4.67 Jutra.
©MJSTP Films Inc. Work-in-Progress.

FIG 4.68 Jutra.
©MJSTP Films Inc. Work-in-Progress.

FIG 4.69 Jutra.
©MJSTP Films Inc. Work-in-Progress.

FIG 4.70 Jutra.
©MJSTP Films Inc. Work-in-Progress.

FIG 4.71 Jutra.
©MJSTP Films Inc. Work-in-Progress.

FIG 4.72 Jutra.
©*MJSTP Films Inc. Work-in-Progress.*

FIG 4.73 Jutra.
©*MJSTP Films Inc. Work-in-Progress.*

FIG 4.74 Jutra.
©*MJSTP Films Inc. Work-in-Progress.*

FIG 4.75 Jutra.
©MJSTP Films Inc. Work-in-Progress.

FIG 4.76 Jutra.
©MJSTP Films Inc. Work-in-Progress.

FIG 4.77 Jutra.
©MJSTP Films Inc. Work-in-Progress.

Exploring Women's Issues One Frame at a Time

Though Canadian director and animator Norman McLaren passed away in 1987 he is still a source of inspiration and a pioneering force in the world of animation and experimental filmmaking. Marie-Josée Saint-Pierre's early impressions of him while she was still a film student continue to significantly influence her visual style and mixed media approach to filmmaking. As a Gen X producer, director, writer, and animator, Saint-Pierre is

passionate about women's issues. She bravely explores the painful and sometimes political matters pertaining to childbirth and motherhood and includes her own personal experiences as a young mother. In *Jutra*, Saint-Pierre returns her focus to the world of Canadian film by educating her audiences about another beloved director and uses her own artistic sensibilities to push the medium of animated documentary forward in personal and unique ways.

Documentary Filmmaking with an Animator's Sensibility: Dennis Tupicoff

Biography

Dennis Tupicoff was born in 1951 and graduated from Queensland University in 1970, later completing the Swinburne Film and TV School animation course in 1977. After working as a writer/ director/producer of his own films as well as TV commercials and other commercial and sponsored work, he was appointed Lecturer in Animation at the Victoria College of the Arts School of Television (1992—94). Since then he has continued making independent films as writer, director, producer, and often designer/animator. These films have been both fictional and documentary, animated and live-action, comedy and drama—and sometimes inventive combinations of various categories.

FIG 5.1 Dennis Tupicoff.

Tupicoff's work has been shown at film festivals around the world, and he has won numerous awards. His recent film *Chainsaw* (2007) has won many Grands Prix in animation festivals such as Ottawa, Animadrid, Anifest, and others, as well as in competition with live-action films at Oberhausen, Huesca, Mecal in Barcelona, among others. Moving between fact and fiction, Hollywood and Spain, past and present, *Chainsaw* is a chain of stories about romance and celebrity, machismo and chainsaws, fantasy and death.

In *The First Interview* (2011), the world's first media interview photographed in Paris in August 1886, finally comes to life as a film. The great photographer Nadar interviews the famous scientist and skeptic Chevreul on his 100th birthday, and this 15-minute documentary will be broadcast on France's Canal+ as well as on Australia's ABC network in early 2012.

Tupicoff's films are often shown in retrospectives. In April 1995, 16-year-old Matthew Easdale was shot dead in a house in Brisbane, Australia. In *His Mother's Voice* (1998), Tupicoff uses the original radio interview with Matthew's mother and uses rotoscoped animation to present the account in two very different ways. *His Mother's Voice* has been included in many programs of documentary animation (e.g., Fantoche 2011, IDFA 2007, Zagreb 2008, and Leipzig 2008) and is discussed at length in several recent books, including *Introduction to Documentary* by Bill Nichols, *The Animation Bible: A Practical Guide to the Art of Animating from Flipbooks to Flash* by Maureen Furniss, and *Australian Documentary: History, Practices, and Genres* by Trish FitzSimons, Pat Laughren, Dugald Williamson. Tupicoff was also featured in Chris Robinson's book *Unsung Heroes of Animation*. Since 2000, Tupicoff and Fiona Cochrane have worked together on various projects as Jungle Pictures Pty. Ltd.

Of Love and Loss

In documentary production, shooting uncontrolled action is known as *actuality*. The audio for *His Mother's Voice* is a radio interview conducted by Matt Brown for the Australian Broadcasting Corporation (ABC), and as Tupicoff incorporates it in his award-winning animated documentary, it is a moving example of audio actuality. The radio interview took place several weeks after Kathy Easdale's son Matthew was shot to death in 1995. She was asked how she found out about her son's death, and she speaks for six and a half minutes about her grief and love for her son. By repeating this powerful audio twice and using a unique animated documentary approach, *His Mother's Voice* observes the very raw emotions of love and loss and enables the viewer to accompany Kathy Easdale in her grief.

FIG 5.2 Still from *His Mother's Voice* drawn by Annette Trevitt.
Printed with permission. ©Dennis Tupicoff 1998.

FIG 5.3 Still from *His Mother's Voice* drawn by Annette Trevitt.
Printed with permission. ©Dennis Tupicoff 1998.

FIG 5.4 Still from *His Mother's Voice* drawn by Annette Trevitt.
Printed with permission. ©Dennis Tupicoff 1998.

Interview

Judith Kriger: *What attracted you to the story of* His Mother's Voice?

Dennis Tupicoff: It was the power of the storytelling and Kathy Easdale's voice. I'd heard it on the radio news at lunchtime, and it was incredibly powerful as a piece of audio. The interviewer said that this young boy, Matthew Easdale, had been shot, and the interviewer was talking to Kathy Easdale. After a few minutes of fairly normal questions and answers, the interviewer asked her how she first learned of her son's death, which is the first sentence you hear in the film. She then continues to talk for about six and a half minutes, and it's one of the most extraordinary pieces of dialogue I've ever heard. During it, I was in tears, and I know other people, friends of mine—one friend who was driving her car while listening to this interview had to pull over. She couldn't drive, she was incredibly upset. I'm interested in affecting the audience emotionally, and I began to wonder why this was so powerful and started thinking about how I could make this into a film given what I'd just heard. It was an incredibly powerful reaction to a piece of audio.

JK: *It's extremely upsetting; I was also in tears when I watched it.*

DT: In the making of the film and in the years since, I've listened to the audio many times, and it still gets to me, and I still think about why it does. We all hear lots of microphone-in-your-face sort of interviews—"Tell us how you feel!"—with all sorts of horrible situations, but there really is something else happening in that bit of audio, something quite extraordinary.

JK: *How would you describe the "something extraordinary" that happened in that audio?*

DT: To me, it's a remarkable sense of storytelling. It's probably innate. My theory is that Kathy Easdale is a natural-born storyteller. This interview was given about ten days after it had actually happened, so she had probably told the story many times, to police and others, so she had probably "rehearsed" it by virtue of telling it many times to different people. In addition, there's an extremely strong rhythm in her voice, which I only discovered when I was "reading" the soundtrack of her voice for lip sync purposes. To me, these things explained why it is so powerful. It has altered my view about what makes sound powerful.

We all speak in a kind of rhythm. In her monologue that you hear in the film, she speaks for six and a half minutes without a break in that rhythm. In fact, you can tap it out on your knee, and you'll see that it's 26 frames per beat, without a break—until fairly close to the end, when she starts getting more upset, and then it goes up to 28. What is song but words in rhythm? She's actually "singing" a song of love and grief to her deceased son. I think one of the reasons it's so effective is because the interviewer lets her go on, and she strikes this rhythm, and she's told it before, and it's therefore exactly like

a song. It's unusual for any interviewer to let someone speak for six and a half minutes.

I was determined to use the original voice of Kathy Easdale in *His Mother's Voice*. I used rotoscoped footage of a performance by Leverne McDonnell, and we had to use a "mime to playback" technique. This necessitated a lot of very careful preparation by the actor; not only learning all the on-screen lines, but also the specific spacing of words, breaths, mouth-sounds, etc.

FIG 5.5 Still from *His Mother's Voice* drawn by Annette Trevitt. Printed with permission. ©Dennis Tupicoff 1998.

FIG 5.6 Still from *His Mother's Voice* drawn by Annette Trevitt. Printed with permission. ©Dennis Tupicoff 1998.

JK: *You repeat the dialogue twice in this film, yet the rotoscoped footage looks different the second time around. The audience can experience the same monologue in a different way.*

DT: When I listened to this radio interview for the first time, I visualized what I was hearing. But I didn't think that was an adequate reason to make the film.

It wasn't enough of a reason to put these colorful, animated images to a piece of powerful audio. I decided that I wouldn't make the film until I had a better premise. I kept thinking about it for about two or three months, and then I suddenly had the idea to do it a second time from a different point of view, and then it sort of all fell into place. There's the "normal" illustrative point of view, showing what the person is saying, which is what a lot of animated documentaries do, and the second part is the real-time approach, showing what was happening around her house while the interview was taking place. The second I thought of that, I knew the film was worth making, and it all happened very quickly after that.

JK: *Are you trying to show how subjective documentary filmmaking is?*

DT: Yes, though it's not my primary reason for making this film. By showing the story in these two different ways, it would show more about Kathy and therefore Matthew's life—his room, the pictures on the walls in their house, the back yard, the bike he used to ride; all sorts of things. I could describe the world that he inhabited. I wanted to do it that way because I was trying to get the interview to happen in more than one dimension. You've got Kathy's descriptions of what she experienced, but there's also the dimension of the past that they had together. This is the dimension from which she's speaking; she's talking about her love for Matthew. This addresses what the interview is really all about. It isn't really about how she learned of Matthew's death; it's really a declaration of love and grief for her son and that's why it's so powerful. Therefore, showing in some way something of their life together seemed to provide another dimension. I didn't set out to make a "weird," experimental documentary, but I'm perfectly aware that I've used the same soundtrack twice. The subtext of what she's saying is, "I miss Matthew, and I'm grieving for him."

FIG 5.7 Still from *His Mother's Voice* drawn by Annette Trevitt.
Printed with permission. ©Dennis Tupicoff 1998.

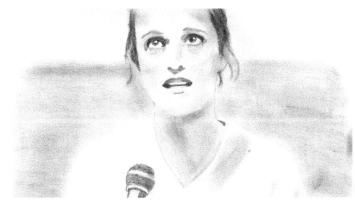

FIG 5.8 Still from *His Mother's Voice* drawn by Annette Trevitt. *Printed with permission.* ©*Dennis Tupicoff 1998.*

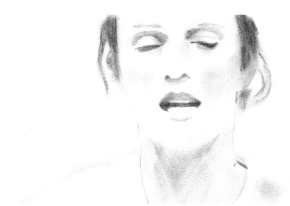

FIG 5.9 Still from *His Mother's Voice* drawn by Annette Trevitt. *Printed with permission.* ©*Dennis Tupicoff 1998.*

JK: *It's interesting to me that you work in animation, live-action, and documentary. Who or what influences you?*

DT: My interests are varied. I've watched a lot of documentary films and I've seen a lot of photographs. My background is in politics and history, and I was an archivist when I first finished university. My interests—and this is really unusual for an animator, I think—my interests are really nonfiction and not in fantasy at all. I'm really interested in documentary and photography. One of the greatest books I've ever read is *Let Us Now Praise Famous Men*, by James Agee with photographs by Walker Evans. This was an amazing book written in the 1930s about the poor white farmers in Alabama. It's an unusual combination of almost Biblical prose and amazing photographs. These are regarded as some of the greatest photographs of the 20th century.

JK: *Would you describe yourself as an experimental filmmaker?*

DT: No, I've seen plenty of experimental films. <laughs> Telling a story from many points of view is not unique, but in documentary to use the same soundtrack more than once is almost experimental, in a way. Documentary people regard this film as pretty "out there." When it was first released, it didn't get into any documentary film festivals, at all. In the whole world—nobody wanted to show it! Now, of course, it gets invited to lots of documentary festivals. When I made it, no one wanted to know about it. You'd have to ask them about it—to me, it was completely obvious that it was a documentary. This was around 1997, 1998, and I was really disappointed. People just didn't want to know that a documentary could be animated.

JK: *Do you think the audience's understanding of documentary has expanded since then?*

DT: I'm sure it has.

FIG 5.10 Still from *His Mother's Voice* drawn by Annette Trevitt.
Printed with permission. ©Dennis Tupicoff 1998.

FIG 5.11 Still from *His Mother's Voice* drawn by Annette Trevitt.
Printed with permission. ©Dennis Tupicoff 1998.

JK: *What first attracted you to animation?*

DT: I saw it as a form of filmmaking that I could do on my own. When I worked as an archivist I traveled overseas and started getting interested in film and shooting in Super 8. Animation is something you can do in a room on your own, it doesn't cost (too) much money, and if you focus you can make something that's never existed before—with a pencil! I made a little cartoon called *Please Don't Bury Me*, because cartoons were all that I could think of that you could do with animation. This was before I went to film school—I was pretty much self-taught. I also didn't have to run around and grab great crews of people to help out.

Even though I've done a lot of animation and in my early career I earned my living doing animated TV commercials, I prefer to write and direct.

Mixing Fact with Fiction

Chainsaw is an award-winning animated chain of linked stories, driven by human dreams and fantasies, romance and machismo. Some of the stories are real, quoted directly from news reports, while others are taken from 1950s newsreels; still other parts of this film are fictional, though based on fact. *Chainsaw's* documentary "feel" is achieved through the artful mixing of rotoscoped live footage, a small article in a newspaper, and newsreel footage that Tupicoff reworks into an inventive part-fact, part-fiction hybrid. *Chainsaw* has won many awards, including several Grands Prix in Europe and North America.

FIG 5.12 Still from *Chainsaw.*
Printed with permission. ©Dennis Tupicoff 1998.

Interview

JK: *How did the idea for Chainsaw come about?*

DT: The roots of *Chainsaw* came from a very small article in the newspaper. I read many newspapers each day, I have all my life. Way back, there was a little clip in my hometown [Brisbane] newspaper that said that Australia's greatest bucking bull, Chainsaw had just died—as if it were some person. The article was written somewhat from a comic viewpoint, and included the comments of Chainsaw's owner, which are also in the film: He could jump so high you could almost run underneath him if you were quick enough. Stuff like this—it was absurd! This was all quoted from the guy. And I just found this incredibly funny, which of course is what it was meant to be. I carried this little clipping, which was only about a 3-inch column, in my wallet for years and—here's the researcher in me—I began gathering research on bucking bulls, on chainsaws, and bullfighting. I then had two stories going: one about

FIG 5.13 Still from *Chainsaw.* Printed with permission. ©Dennis Tupicoff 1998.

FIG 5.14 Still from *Chainsaw.* Printed with permission. ©Dennis Tupicoff 1998.

Chainsaw the bull, and another on bullfighting. Ernest Hemingway had written about a famous bullfighter in the Fifties named Dominguin, and so I boned up on him.

FIG 5.15 Still from *Chainsaw*. Printed with permission. ©Dennis Tupicoff 1998.

I suddenly realized that if I add a fictional story to the two factual ones, that would bring it together. Dominguin was Ava Gardner's lover—in fact, the Spanish people still talk about him! If you talk to a Spaniard older than, say, forty, they'll say, "Yeah, they were hot!" <laughs>

FIG 5.16 Still from *Chainsaw*. Printed with permission. ©Dennis Tupicoff 1998.

Then I made up the parallel story to link Chainsaw the bull with Dominguin the bullfighter. This is the joy of research—my wife tells me that research is what excites me, and she's probably right—looking for footage of Ava Gardner, I came across footage of Gardner sitting at a bullfight seeing a guy being gored by a bull. I couldn't believe it! It wasn't Dominguin, though he was at that same bullfight. It's an amazing piece of footage, and my favorite part of the film is seeing her face when the guy was gored because it really

did happen. The movie star "mask" was gone, and you can really see the shock on her face. That was a great stroke of luck, and I had a lot of fun putting those stories together and calling them Frank and Ava.

JK: *You've done a lot of rotoscoping in your films. Do you have a favorite animation technique?*

DT: Mostly I work in drawn animation, and I'm content with that. When I worked on commercials I used to draw the animation on paper or cels; now I use 2D animation software made by Toon Boom. There is some CG in *Chainsaw*: the vehicles were done by David Tait, who was my collaborator in the special effects. More than anything else nowadays, I'm really interested in writing and directing.

FIG 5.17 Still from *Chainsaw*. Printed with permission. ©Dennis Tupicoff 1998.

The First Interview

The world's first media interview, shot in Paris in August 1886, finally comes to life as a film.

The great photographer Félix Nadar interviews the famous scientist and skeptic Michel Eugéne Chevreul on his 100th birthday. The photographs and the original words of the interview were published in *Le Journal Illustre* in Paris on September 5, 1886. As a series of unposed portraits it is remarkable; as a photographic and stenographic record of an interesting and sophisticated conversation from 1886 it is unique.

In their own words—originally recorded in shorthand—Nadar and Chevreul discuss photography, color theory, Moliere and Pasteur, the scientific method, the crazy ideas of balloonists, and—of course—how to live for 100 years. *The First Interview* is a lively and interesting conversation between two legends of the 19th century: one born before the French revolution; the other destined to see the marvels of the airplane and the movies.

Interview

JK: *I was reminded of Muybridge when I watched this film. I would describe* The First Interview *as a live-action documentary film with an animator's sensibility.*

DT: I think you're probably right. The average documentary person probably wouldn't make this film. I've done lots of kinds of films, but with my animation "hat" on, I'm quite able to look at every frame and say, "Well, I can change that frame, and once I've done that frame I can change the next one, or I can create a frame out of nothing."

Documentary people go on about "reality," and I think they're misleading themselves a lot of the time. From my point of view, a lot of documentaries are formula. I've made documentaries, and I know how they work: you have an interview with somebody, and you show their work or whatever they've done, and you include interviews with some "experts," some people who knew them, and you add some music and some narration . . . and you have a documentary! It's a pretty boring recipe. The film makes an argument, obviously, or presents the biography of someone. Whether it's the "truth" or not, I think documentaries are every bit as fantastical as an animated film. And this is coming from someone who has a great love for the photographic image. I'm just very skeptical about some of the claims that come from documentaries such as, because they're filmed images, it's "true." We know that this is nonsense—or rather, it may be nonsense. Documentary festivals didn't want to screen *His Mother's Voice*, presumably because of some idea that it wasn't "reality" or wasn't really documentary. I certainly think that there's more reality and more real human feeling in *His Mother's Voice* than in a truckload of documentaries that I've seen. As you can see, I'm a bit skeptical. That's not to say that I don't love documentaries, it's just that some of the claims that people make for them tend to pretend that there's not a lot of "artfulness" or "mistrustful" techniques that are used. We all see all sorts of message documentaries about all sorts of issues where you know from the first minute about the point of view from which it's being made.

I've made some live-action documentaries. I made one about an artist and one about an architect. In the one about the architect, I didn't use any interviews with the architect nor did I use any interviews with any experts. In the one about the artist, I relented a little bit and I did interview the artist, but I didn't use any interviews with any experts, critics, or academics. It frees you up so much; you have so much time! <laughs> You don't have these talking heads! My pet hatred in documentaries is talking heads, because so often it's just a way of filling up screen time. I end up looking at the texture of the curtains behind the person talking, or what sort of shirt they're wearing, or wondering how much their glasses cost. <laughs> It's so much screen time that you're better off looking at something else.

JK: *What inspired you to make* The First Interview?

DT: About eight or ten years ago, I saw the photographs of this interview in a book. Part of the text of the interview was also published. There were only about eight or ten photographs of these two guys sitting at the table talking, of the actual interview. If you have photographs and the text of the interview, it seemed like an obvious thing to make a film out of it. And if you're an animator, of course, you just want to bring those pictures to life. In my head, I could see them coming to life. Of course, the reality of getting them to screen was not that simple.

JK: *What were some of the challenges in making this film?*

DT: The biggest challenge was how to make it. The way I wanted to make it was to have used CG and motion capture to bring the two people in those eight or ten photographs to life. We would have used actors for the mo-capped data and applied their performances to rigged CG models. Complicated, but I was very keen to do it. Unfortunately, we got estimates of what it would cost: over half a million dollars. This is for five minutes of material! Even though everyone thought we should do this, no one was going to pay that sort of money for a short film.

I had to find another way of doing it, and so the alternative was to make it using actors and prosthetics and make them look as much as possible like the people in the photographs. I think we succeeded pretty well. Even if we had done it in CG, people would have known that it was fake, because we say up front that the interview had happened before the advent of cinema. In an entertaining way, it presents this interview as if there had been a movie camera cranking away.

We set out to make a 100% French language production, as well as a version with English narration and subtitles. Though both of our Australian actors speak French, the best French-language voice actors were in France (as was our narrator). But the rest of our production, and particularly our prosthetic specialist, was based in Melbourne. So we recorded all the voices in Paris (all separately, in fact), edited them there, and used them during rehearsal and the shoot several months later, here in Melbourne.

In between there was a great deal of work by the actors—particularly Nicholas Bell, who plays Chevreul—to learn all the lines as well as all the other details mentioned above. Like Leverne McDonnell [in *His Mother's Voice*], the actors in *The First Interview* did a great job. So good were they, in fact, that we sometimes had to make the sync more faulty to fit my idea of what 1886 sync-sound might have been like.

The Healthy Skeptic

At the time of its completion, *His Mother's Voice* was not accepted into any documentary festivals. Would the same hold true today? Do audiences and documentary film festival programmers now have a broader understanding of the documentary form?

Chainsaw intelligently mixes Dennis Tupicoff's appreciation for documentary with fictional events and demonstrates his wry sense of humor. With a love of both animation and live action, Tupicoff's films dare audiences to redefine the possibilities of nonfiction filmmaking. Having made documentaries himself, Tupicoff well understands the popular perceptions of this genre, yet he advocates for documentary films to incorporate more of an exploration of emotional truth, not just the truth as typically defined by shooting live footage of historical events or talking heads. In *The First Interview* Tupicoff takes an actual interview and photographic portraits, inventively reimagining the event as if it had been shot on film. Is his version of Nadar and Chevreul's interview any less truthful than the original? By incorporating an animator's sense of timing and imagination into his innovative films, Tupicoff challenges the viewer to rethink the "rules" for documentary production, thereby enhancing this continually evolving art form.

Making Ordinary Human Experience Extraordinary: Chris Landreth

Of Trips to the Moon, Teapots, and Spaceships

Within the world of film production, computer graphics is the new kid on the block. In a period of only 50 or so years, CG production has revolutionized today's feature film, TV, commercial, Web, and gaming industries. There are numerous major players who have contributed their innovations to this exciting, ever-changing part of the production pipeline.

Though Georges Méliès produced his films long before the digital revolution took place, it can be argued that he is one such influential player. Méliès's films introduced numerous visual effects concepts such as compositing, the art of

FIG 6.1 Chris Landreth.

combining different types of filmed images that are made to look as if they belonged in the same world and were shot at the same time. These visual "tricks" are commonplace today, albeit with higher production values due to the sophistication of the tools. Though Méliès's well-known 1902 film *A Trip to the Moon* may look "crude" to modern eyes, it actually shows an advanced and sophisticated understanding of creative visual effects production techniques.

In 1975, Martin Newell was a computer graphics researcher at the University of Utah who created a 3D computer model of an ordinary teapot as a means of providing a scene and lighting setup. Nowadays, the Utah teapot is a sort of "in-joke" in the CG community, and teapot models are paid homage to in movies like *Toy Story*, which was released in 1995 and is the first full-length computer generated film. Currently, teapot models are included in high-end professional CG software as default modeling and texturing references.

Another of the earliest and best-known pioneers in the world of computer graphics is James Blinn, who early in his career worked for NASA's Jet Propulsion Laboratory (JPL) in Pasadena, California, and used early CG animation to simulate Voyager 2's spaceship explorations. Blinn is also known for writing the Blinn shader, code that determines how light effects the CG models contained in a scene and used on a regular basis in feature films, TV shows, and video games.

George Lucas has revolutionized animation and visual effects in both the optical and digital realm, and his effects house, Industrial Light and Magic, continues to be known the world over for its stunning, breathtaking work. ILM redefined visual effects in *Star Wars*, the movie that launched Lucas' empire. In the inventive *Who Framed Roger Rabbit*, director Robert Zemeckis and ILM artists created a world in which humans coexisted with cel-animated characters. Zemeckis later said that working on that project was "like directing a movie with the volume turned up to full blast" Industrial Light and Magic: Into the Digital Realm. Another breakthrough movie for the power-house visual effects studio was *Indiana Jones and the Last Crusade*. Released in 1989, this was ILM's first production with all-digital compositing.

Pixar's massive success is due, in part, to the talents of Oscar-winning director John Lasseter. Not only a gifted artist and animator, Lasseter also had the foresight to see the potential artistic future of computer graphics. In its early days much of CG was not terribly appealing; character animation was limited to being created with simple, primitive shapes, and rendering horsepower was nothing like the tremendous options available nowadays. Lasseter's early, persistent drive to keep pushing science so that it would better suit the art is a major achievement in feature film production as well as in digital technology overall.

CG is the perfect, yet intensely complex marriage of art and science. Captivating character-driven computer animation and photorealistic visual effects are more prevalent than ever, thanks to increasingly powerful hardware combined with state-of-the-art CG capabilities such as subsurface

scattering and image-based lighting techniques. It is an exciting time to be a part of this demanding and challenging art form.

To truly blossom in the digital arts, one must ideally be an artist who also enjoys understanding the technology of what goes on "beneath the hood." Programmers who work in visual effects, animation, or games must constantly problem solve and patiently troubleshoot when a piece of their code doesn't achieve the desired result. Artists and animators must also visually troubleshoot to determine the right "look dev," motion, or timing of a character using their artistic sensibilities and talents, while simultaneously wrestling with rapidly evolving hardware and software.

It Takes a CG Village

Producing and creating a CG film takes a village plus the implementation of a production pipeline, an action plan that outlines the order in which each step in production will occur and that is of a slightly different nature than those used in hand-drawn animated productions. Whether for feature-length films or animated short, pipelines are necessary so as to better manage the numerous "ingredients" or assets in the film. A typical feature-length CG pipeline can include the following departments: Story, Art Department, Editorial, Modeling, Articulation, Shading, Digital Paint, Layout, Set Dressing, Animation, Lighting, and Rendering. The necessary steps in short CG-animated films are really no different; however, individual artists and/or programmers may be working on each step of the pipeline instead of entire departments of people.

The Editorial department cuts together Leica or storyreels: a first pass of what the film will eventually look like using the storyboard drawings created by the Story department and a rough, scratch soundtrack.

FIG 6.1A A wireframe CG model.

The Modeling department is responsible for sculpting the characters, props, and sets based on designs created in the Art department. Some studios start their models in clay or latex and then digitize the final results to bring them into the CG world. Further modeling refinements may then be made using (currently) popular high-end CG software such as Maya, 3D Studio Max, Softimage, Houdini, or in the case of large studios, high-end proprietary software. Character Technical Directors (Character TDs, for short) work in the Articulation department and are responsible for creating the rigs; the skeletons inside the characters that will allow the animators to pose the characters and in essence be the actors behind the camera. The Shading department creates the "look" of the final rendered images by designing the bumpiness, shine, and/or colors of each shot. The Layout department works with the directors and the storyboard panels to rough in the camera motion and framing of each shot, and artists in the Lighting department influence the mood through the illumination of each scene, just as a DP would do in a live-action film, by designing lighting rigs and patterns and shapes of shadows.

Biography

Computer graphics has its roots in both art and science, and having an understanding of each form of creative problem-solving makes for a more satisfying career. Because CG software is ever-changing and has a steep learning curve, it's ideal for digital artists and animators to cultivate a patient interest in understanding how software works, which will serve well when the inevitable technical problems arise.

Chris Landreth received an MS degree in theoretical and applied mechanics from the University of Illinois in 1986. For three subsequent years, he worked in experimental research in fluid mechanics at the University of Illinois with his advisor, Ronald J. Adrian. Landreth was responsible for developing a fluid measurement technique known as Particle Image Velocimetry (PIV), which has since become a fundamental way of measuring fluid flow. He received two patents for his work on PIV during his time at the University of Illinois.

In 1989, Landreth studied computer animation under Donna Cox, at the National Center for Supercomputing Applications (NCSA). It was at this point that he created his first short film, *The Listener* (1991), a film that won him notoriety by being shown on MTV's *Liquid Television* the following year.

In 1994, Landreth joined Alias Inc. (now Autodesk Inc.) as an in-house artist. It was his job to define and test animation software before it was released to the public. His work was one of the driving forces in developing Maya 1.0, in 1998. Today Maya is the most widely used animation and VFX software package in production, and Alias subsequently was given an Academy Award for this in 2003.

As part of the development of Maya, Landreth directed and animated two short films, *The End* in 1995, and *Bingo* in 1998. *The End* earned an Academy Award nomination for Best Animated Short Film in 1996. *Bingo* received the Canadian Genie Award in 1999 for best animated short film, and was ranked 37th in the "100 Most Influential Moments in CG History" by *CG World Magazine* in 2003.

In 2004, Landreth released a 14-minute animated documentary called *Ryan*. *Ryan* very quickly became one of the most celebrated animated short films of all time. Chris tells this story using strange, detailed imagery that combines CG photorealism with metaphorical flourishes that reflect the emotional and spiritual states of its characters. Landreth refers to this approach as psychorealism." *Ryan* has been embraced by the world of animation in an unprecedented way. It received the 2005 Academy Award for Best Animated Short Film and over 60 other international awards.

In 2009, Landreth released *The Spine*, an unsettling exploration of a troubled marriage of two people in their mid-50s, and choices that are both tragic and beautifully redemptive. This film was nominated for a Canadian Genie award and was one of "Canada's Top Ten Films" of the Toronto International Film Festival Group in 2009.

In creating these films, one of Landreth's primary passions has been the study of the human face and the application of this knowledge to his characters' faces. He is an expert in facial anatomy and the Facial Action Coding System, developed by Paul Ekman, a San Francisco-based clinical psychologist who specializes in researching emotion and its expression, and used by animation studios worldwide to create facial animation. Landreth has taught programs in Facial Animation at Seneca College, the University of Toronto, TRUEMAX Academy in Denmark, and DreamWorks Animation in California. In April 2011, he received a Guggenheim Fellowship for his animated filmmaking and for the development of his upcoming short film, *Subconscious Password*.

The Art of Walking

Working as an animator requires a sometimes dizzying array of skill sets and talents, ranging from the technical to the artistic and necessitating a kind of Jack- or Jill-of-all-trades background. Not only does today's animator require a fluency with ever-changing and complex, high-end software applications and operating systems, but also and more importantly, being an animator requires a keen understanding of art theory, art and film history, and the ability to produce creative work in traditional media such as drawing, painting, and sculpture. Software can only record the key framed bases on mathematical values; it's up to the animator to have the artistic eye for creating strong poses, an actor's sense of timing, and the knowledge to apply the principles of animation. Animation requires a detailed understanding of

human and animal anatomy as well as the mechanics of motion; today the common misperception is that the computer will "do it all for you." How do the bones in human or animal skeletons affect the motion of the character? What exactly do our bodies look like when we walk? The ability to understand all of this at an advanced level truly requires the discipline of lifelong learning.

FIG 6.2 Walking.

Long before computers became a mainstay in the world of animated films, the late Ryan Larkin, a Canadian artist and animator directed his beautiful, Oscar-nominated short *Walking*, in 1969. Larkin's film uses only pencil, paint, and paper to elegantly explore how our bodies move when we walk. Tall and short, heavy and light, young and old, male and female . . . all varieties of bodies in motion are portrayed in *Walking*, with the grace and quiet eloquence that only a gifted artist or animator can demonstrate. Larkin was the subject of Landreth's Oscar-winning animated documentary, *Ryan*.

Interview

Judith Kriger: *What comes across to me in* Ryan *is your love for the medium of animation. Can you tell me a little about that?*

Chris Landreth: When I talk about animation, I tend to do it differently than a lot of other animators that I know, because I think that animation—in the

case of *Ryan*—is capturing real life, reality. It's being able to distil down what we human beings do in everyday, ordinary life, and turn it into something—I hope, anyway—extraordinary or magical.

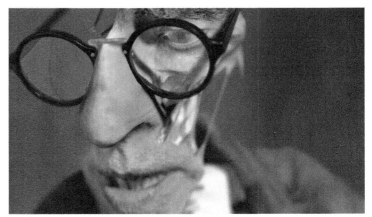

FIG 6.5 Ryan.

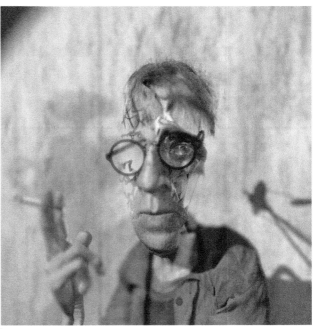

FIG 6.6 Ryan.

JK: *How did* The Listener, Bingo, *and* The End *lead you to* Ryan?

CL: I'd say that the common thread through all those films is very much a psychological element. I'm not just trying to show fantasy, I'm not just trying to show cool things, I'm always trying to get into the emotional, intellectual, and spiritual head-space of the main characters. I'm still really obsessed with introducing a psychological head-space into the 3D space of what the audience is seeing.

In *The Listener* and *The End* I was trying to be spiritual. Particularly in *The End*, where she says she's created her own ending. At the time, I was reading a lot of works by Robert Anton Wilson, who talks a lot about transactional psychology and the idea of free will and being able to control that. I carried those themes through, and then when I did *Bingo*, I was exploring the flip side of that: where you do not have that kind of control, and what happens to your sense of self and your emotional state as a result. There's always been a sense of "self" in my films.

JK: *A sense of "self," meaning describing the self, or . . . ?*

CL: How self-awareness works, and how it manifests, and how to portray that visually. It's something I've always done and I'm still doing, actually. This film I'm working on now takes place entirely in the subconscious of the protagonist.

FIG 6.7 Ryan.

JK: *One of the many parts of* Ryan *that really stood out to me is where you show Ryan Larkin's drawings from his film* Walking—*it almost looks like a flipbook. Students today would describe this as "old school" animation.*

FIG 6.8 Walking.

FIG 6.9 Walking.

FIG 6.10 Walking.

CL: I don't generally make the distinction that the piece from *Walking* is "old-school" animation, per se. For me, it was actually quite radical when it was made—and still radical today, because what he did was take ordinary human experience and make it extraordinary. In *Walking*, he's not doing over-the-top cartoony stuff, and he's not trying to "wow" you with any kind of visual effects. What's so incredible to me about *Walking* is that he's taking something we take for granted, something we do every day. When a film like this is able to show something that we might consider mundane or dull and instead show that it's actually quite miraculous, that's when it becomes a work of great art, I think.

JK: *I would agree with you there. He's analyzing walks, and you can really see the beauty in it.*

FIG 6.11 Walking.

FIG 6.12 Walking.

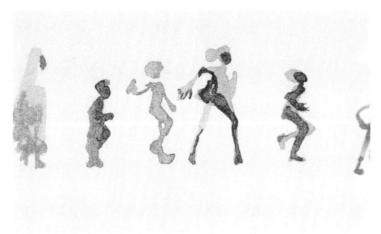

FIG 6.13 Walking.

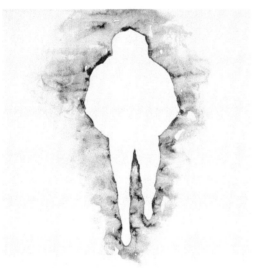

FIG 6.14 Walking.

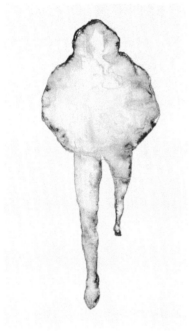

FIG 6.15 Walking.

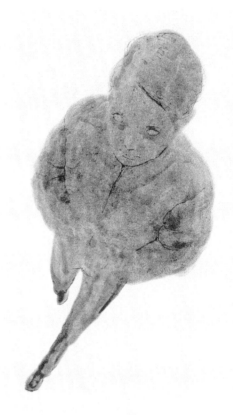

FIG 6.16 Walking.

JK: *It's interesting to me that you saw the potential of making an animated documentary in CG. Most filmmakers who are fusing the two genres together are working in 2D. How did you know that it would work—or . . . did you know that it would work?*

CL: Well . . . no one knows at the onset of doing something like that if it's going to work, so it's always a crapshoot. I came to have a feeling that it was going to work, though—the "look" that you saw in *Ryan* was something that I was really seeing from the very beginning, that you're showing people's souls or mental states or psyches, or however you'd like to term it as. These visuals are symbolic representations to show a person who was literally decimated, or literally self-aggrandizing, or literally vague. Why not turn something that is real into something that is symbolically visual on the screen?

FIG 6.17 Ryan.

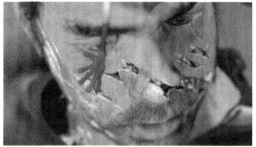

FIG 6.18 Ryan.

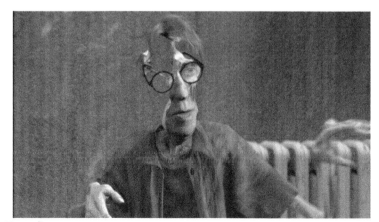

FIG 6.19 Ryan.

147

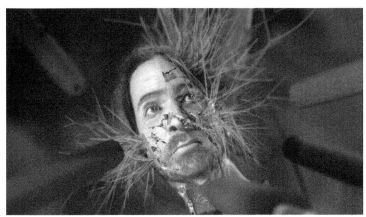

FIG 6.20 Ryan.

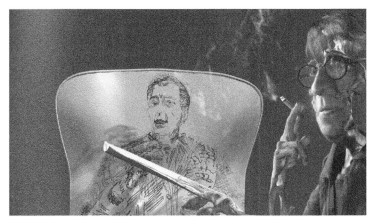

FIG 6.21 Ryan.

Yea, Though I Walk Through the Uncanny Valley

While James Cameron's *Avatar* broke box-office records, movies such as Disney's *A Christmas Carol* and *Mars Needs Moms*, did not. In early 2011, Walt Disney Studios closed ImageMovers Digital studio in San Rafael, California, stating that each movie had "underperformed" and causing many hundreds of people to be laid off. The critics were not kind to Robert Zemeckis and his ImageMovers Digital movies; some reviewers stated that *Mars Needs Moms* "killed" motion capture, or mocap. In order to determine why movies such as *Avatar* succeed using this technology while others do not, it's first important

to understand what goes on behind-the-scenes with respect to this technological trend.

Even outside of the visual effects community, most audiences today are aware of actors like Andy Serkis, who is responsible for popularizing mocap with roles like Gollum and King Kong. In the near future, Serkis's acting for mocap CV will also include the soon-to-be-released features *Rise of the Planet of the Apes, The Adventures of Tintin: Secret of the Unicorn, The Hobbit: An Unexpected Journey*, and *The Hobbit: There and Back Again*.

Generally speaking, mocap is created by placing markers on actors by having the performer wear a special tight-fitting suit with attached markers. The actor then goes into a "volume," a space containing hundreds of special cameras that record the data created by the markers as the actor performs. This data then gets plugged into high-end CG software and can be transferred to a CG creature or character, thus allowing for the CG character to inherit the motion of the mo-capped performer. In general, the mo-capped data does not come out perfectly and needs to be "massaged" in order to get the motion to look right.

There are actually various categories of motion-capture technology, including markerless, passive, active, inertial, and mechanical systems. Mova's markerless Contour system is based on fluorescent makeup, not markers, and was made popular when Brad Pitt's facial expressions in *The Curious Case of Benjamin Button* were used to help "drive" the CG facial models in Digital Domain's Oscar-winning visual effects.

Active optical mocap works by having special cameras record the light being emitted by LED-based markers attached to the actor's special mocap suit. The cameras used in passive optical mocap record the light being bounced off reflective markers, while in the inertial category, sensors track the motion of each part of the actor's body. With the mechanical system, a mechanical exoskeleton records the motion of the performer's body parts.

Masahiro Mori is a Japanese expert in robotics and in the human emotional response to humanlike machines. Mori developed a theory known as the "uncanny valley," which posits that as robots become more like humans, they appear completely believable to us until we begin to notice subtle imperfections in the robot's appearance and/or in the way in which it moves. At that point, the robot has a sort of eerie, "zombie-like" appearance and the illusion is completely lost. The uncanny valley is something that CG artists and animators must wrestle with on an ongoing basis, especially when developing and creating convincing character animation for features, shorts, or commercials. *Polar Express, A Christmas Carol*, and *Mars Needs Moms* are just some of the many movies that walk through the shadow of the uncanny valley.

Interview

JK: *There are animators who feel that it's difficult to get an audience to respond to CG in the same way as they respond to hand-drawn animation, because CG is so "perfect" looking. How do you feel about that?*

CL: The uncanny valley is a phenomenon that artists have known about for decades now. It's kind of a pop-culture term, at this point—*30 Rock* even used that term a while ago. That's the thing with CG: you are now able to approach reality, and one of the "edicts" of the uncanny valley is that it's dangerous territory—dangerous, that is, in terms of alienating the audience. I think it's pointless to just try and re-create reality with CG, unless you're making the case that it's cheaper to do it that way than to actually capture the footage of real people. We're not at that point yet, but I can imagine that someday it will be more economical to rig and animate CG characters rather than going to the trouble of dealing with actors. There's that kind of "threat,"—which at a gut-level, people don't like—quite understandably. It's pointless to do it in CG, unless you're adding something to it with respect to the animation that you can't do with live action.

That's what I was trying to do with *Ryan*. I like realism—I can get kind of obsessed with creating models or characters that are realistic, but when I do that I try and find the point of doing that that's aesthetic. The point in the case of *Ryan* was to add stuff to the reality to make people understand why I'm going so far into realism—not so that I'm fooling people into thinking that they're real characters, but so that I can show the reality along with this kind of symbolic fantasy stuff that helps to tell the story. I can tell a different layer of the story that would be much more difficult or even impossible to tell with just live action.

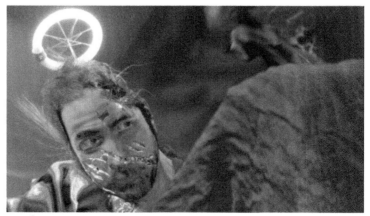

FIG 6.22 Ryan.
©2004 Copper Heart Entertainment Inc. /National Film Board of Canada. All rights reserved.

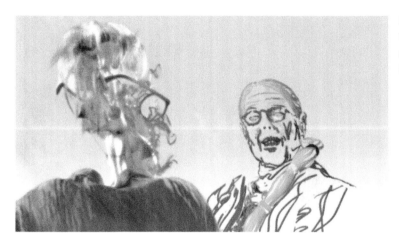

JK: *Is that what you have described as "psychorealism"?*

CL: Yes, sort of, in a nutshell. It's sort of a branch of it. I'd rather describe it in the way I just did than really use that term.

JK: *When you look at most kinds of animation, you can see the imperfection in it. To me, that's part of the "charm" of working in and watching this medium—you can see the human behind the camera. Do you think there's a way to bring that sort of charm into CG?*

CL: It's difficult to do that. In stop-motion [puppet] animation, for example, one of its strengths is that it's direct. You're actually seeing footage of something that's real. You can pick the thing up. You can knock it over, if you're clumsy. You can put a thumbprint in it if you're working with clay, but there's no such equivalent in CG. If you make any kind of "flaw"—if you can call a thumbprint a flaw—it wouldn't read as a thumbprint, it would read as . . . uh oh . . . you set that keyframe incorrectly.

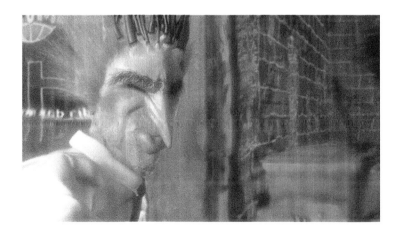

151

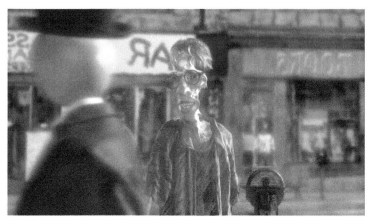

FIG 6.25 Ryan.

JK: *As a CG director and artist, is that something you fight against?*

CL: What really good CG animated films do is they take elements of reality and stylize them, but stylize them in very deliberate ways. I mean, if you look at the development process that feature films at Pixar go through, they don't start modeling with the CG characters, they start with real maquettes, as you would do with stop-motion. They create clay figures, and they make sure that those characters—they may be an 18-inch high sculpture, something that you can touch and turn around and look into his or her eyes—they make sure that you can first get to know that character through the sense of touch before it gets digitized and goes into CG-land. It's a great question. It would be interesting to introduce flaws into a CG digital space and have them read as a "charming" imperfection as opposed to a "creepy" imperfection.

JK: *That's why I think it's so fascinating that you chose to make an animated doc in CG. I think, in a way, it's more intuitive to do it as hand-drawn animation.*

CL: I think that when I do my animation, I'm not trying to "charm" people. If I tried to do that, I'd probably come up short, so I try and go in a different direction. My work tends to be more on the "dark" side ... not so much on the charming side. <laughs>

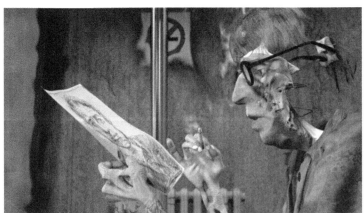

FIG 6.26 Ryan.

JK: *In terms of your art, who or what influences you?*

CL: As far as the animated documentary part of it, I would say Aardman. They weren't the first to do animated documentaries—I think the first real animated documentary was done by Winsor McCay [*The Sinking of the Luisitania*], that sort of started the ball rolling. Not much happened after that, just sort of sporadic stuff. Disney did propaganda films during WWII such as *Victory Through Airpower*. But as far as doing actual documentary, as in having the audio of a real person being documented as opposed to a staged voice, you'd have to look at Aardman's stuff from the early 1980s going up through *Creature Comforts* and the continuation of *Creature Comforts*. They also did TV commercial spots in England for promoting electricity as opposed to using gas-powered items. I was in London on a trip and happened to catch one of those spots. Though it was just a commercial, they were using Creature-Comforts-like creatures who spoke about the advantages of using an electric stove. When I saw that I was kind of mesmerized by it. I had seen other work of Aardman's prior to that spot, but that really hit the point home that you could do something that was really complex, three-dimensionally. They took something ordinary—in that case, characters talking about cooking scrambled eggs on a stove—and turned it into something extraordinary. From watching it, I actually had a whole new feeling about what it's like to cook something on a stove. When I saw that, I thought, "I've got to try doing this!"

JK: *Are there other artists in other media who inspire you?*

CL: As far as visual artists . . . Francis Bacon and a Polish artist named Zdzislaw Beksinski. He was a Surrealist and passed away about six years ago. He did some great, complex oil paintings reminiscent of Giger's work, but I think he even went beyond Giger's work. He did these great anatomically detailed alternate universes of creatures.

FIG 6.27 Ryan.

JK: *What aspect of your previous career in science informs your current career?*

CL: Right now, I'm working on a piece of test footage for my next short film. The footage involves a tentacle of an H. P. Lovecraft monster wrapping itself around H. P. Lovecraft himself; it's actually a comical scene. I'm dealing with the tentacle's behavior in terms of how it responds to airflow and turbulence. I'm working on the mass of the tentacle, how much "drag" it has in the air, and although it's been a couple of decades since I've done anything serious with fluid mechanics, there is constantly science behind the animation I do. So . . . compared to a lot of other animators, I'd say that I take a more technical and analytical approach. I use the science all the time; it's a blessing to have that. It doesn't get in the way of the art; I think it complements it.

JK: *Why did you leave science?*

CL: I got my Master's degree in theoretical and applied mechanics in 1986, and at that time, I was already doing a lot of fine art on my own; I was doing exhibits in Champagne-Urbana, Illinois. As far back as I can remember, I was doing both artistic and scientific stuff.

I really wanted to do something that was more artistic but didn't altogether abandon the science. After I graduated, I was doing research in fluid mechanics in a lab at the University of Illinois for about a year. Down the street from where I was working, a new computer animation program was opening, run by Professor Donna Cox. I was curious about it, so I began to make computer graphics and computer animation. At that time, the program was called Wavefront. Over the next three years, that got me into doing more animation and character animation than working in fluid mechanics.

The Spine and Current Projects

Interview

JK: *Is it more powerful to watch an animated doc than just watching the live footage on its own?*

CL: Yes, I think in the case of *Ryan* that's true. If that had just been a live-action film, I think people would have drifted. What I was trying to show there was—what I'm bringing to it is certainly very *un*documentarylike, because I'm messing with the image. I think purists would say that I'm deviating from the documentary form because I'm adding "fiction" to it. I don't have a problem with that; I think that most if not all documentaries I've seen have some element of—if you don't want to call it fiction—subjectivity, and that's what gives the narrative of the piece something personal from the filmmaker, whether or not they choose to admit that. It's still there. Obviously, Michael Moore's films are a good example of that, or Morgan Spurlock. In this case, I think the point is to be honest about the story you're telling, and I tried very hard to approach making *Ryan* with that sense of honesty.

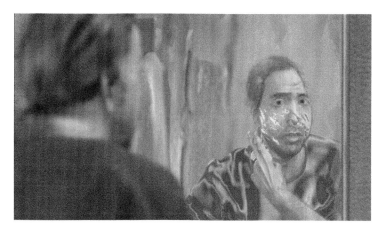

FIG 6.28 Ryan.

JK: *I think that comes through. I'm trying to define what makes some animated docs especially powerful. Yours being one example, and* Waltz with Bashir *as another example. To me, it's because I am always aware of the human behind the camera, and I am able to see the truth—the filmmaker's truth, that is. That's what attracts me to this combination of the two genres.*

CL: Yes, it's a counterintuitive clash. I think *Waltz with Bashir* is so powerful because there's a distilling process that happens. They've visually distilled it down to the stuff that's the most important, and it's visually direct. Ari Folman and his team—they aren't fooling around with their story. The images are there to support the story in a great, faithful way. It's a very direct, honest story.

JK: *What are you currently working on?*

CL: It's not a documentary in any sense. I can't describe too much about it, however . . . it's basically a personal recollection of the zillions of times that I've been at parties and been unable to remember the name of the person who's come up to me, given me a hug, and said "Great to see you again! How's it going?" So . . . it takes place in the subconscious of the protagonist. Basically what happens is, a game show of *Password* is occurring in the person's brain while he's in this predicament of trying to remember who the other person is. It will be finished in 2012.

JK: *I look forward to seeing it! Where did your idea for* The Spine *come from?*

CL: I've seen a lot of couples who have been together for a long, long time who are really unhealthy being couples. I sometimes get frustrated—and want to tell one or each of them—"Look, you guys are toxic to each other." It's a little judgemental to say that without knowing why people are together. So when I was writing a script, it was a very angry script about these two people who were no good for each other.It was a very snide tone, what I was writing. Then I looked at it a few months later and was horrified at the tone I had taken—it was just so toxic. So I tried to rewrite the script from the point of view in which this couple who were living together actually made sense, that there was some reason that was even quite beautiful or noble—even if it's a bit perverse in being that way. That became *The Spine*. I wrote the script as part of a screenwriting group. We were sharing scripts, and we realized that I should make a film out of it.

FIG 6.31 The Spine.
©2009 National Film Board of Canada.
All rights reserved.

FIG 6.32 The Spine.
©2009 National Film Board of Canada.
All rights reserved.

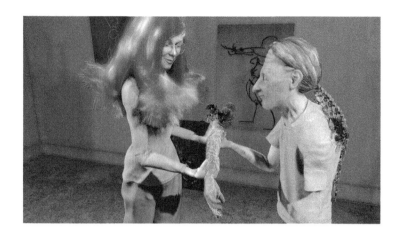

JK: *How is the writing process for you?*

CL: I'm not a writer. I write stuff, and sometimes it's good and I'm really proud of what I did—I wrote the scripts for the films you've seen—but I am not a writer. I find it excruciating. I don't like writing; I like having finished the writing. For me, writing is not the fluid process that a lot of writers will tell you they experience. I was at a film festival where a screenwriter said, "If you're not writing fluently eight hours a day, you probably can't call yourself a writer."

JK: *Once you eventually get through the script, do you do the boards or do you get someone else to do them? How do you work?*

CL: The last couple of films I did thumbnails. I know a couple of people who are really good at turning my scribbles into actual storyboard panels. From then, it's doing a Leica reel and developing the audio and then doing layout, modeling, animation, lighting, rendering, compositing, etc.

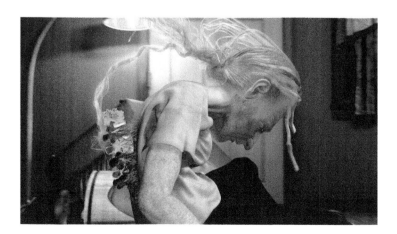

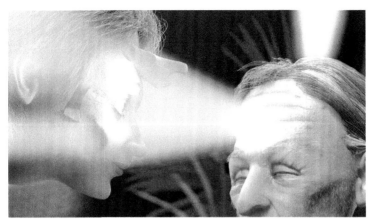

FIG 6.35 The Spine.

Tell Me No Lies

Developing one's creative process is a lifelong journey. Part of this journey, as it relates to the CG profession, entails building an understanding of human anatomy and the mechanics of how the human body works. A solid knowledge of facial muscles and cultivating an understanding of expressions help to determine the believability of animated characters, be they hand-drawn or CG. Paul Ekman is a California-based psychologist who studies human emotions and how they relate to facial expressions. Ekman's research shows that facial expressions of emotion are not determined by culture and are therefore universal. He developed the Facial Action Coding System (FACS), which categorizes every human facial expression as well as other nonverbal behaviors (involuntary body language, for example) and is the inspiration behind Fox's dramatic series *Lie to Me*. Because character animators are essentially actors behind the camera, Ekman's FACS has become significantly important to the professional animator's ever-increasing toolkit and a resource that has had notable consequences for Landreth.

Interview

JK: *Are you still involved with teaching?*

CL: I'm not a fulltime teacher—I do a "traveling show" of teaching. It's a course on facial animation. It's fun to teach, and animators seem to have a lot of fun taking it. It's about 40 hours of instruction, and it's about being able to look at facial cues, look at the way people talk, look at the way people use their eyes and the way they smile—sometimes it's a crooked smile, sometimes it's a smile that shows that there's pain beneath. We look at the things that are happening beneath the face. What are the muscles that are

159

being used to give the infinite variety of expressions? I show a lot of footage of real people, and I show a lot of animation to show how this translates to an animated character.

FIG 6.36

JK: *Do you also talk about the acting process in animation?*

CL: Yes, a lot of acting. In my course I bring my students through a lot of exercises to get them to express themselves in a genuine way in front of the camera.

JK: *Do you work with any of Paul Ekman's research?*

CL: Yes, I'm constantly referring to him. I got to meet him last year; he's great. What he focuses on is our expressions, how our emotions show up. His work is pretty much responsible for all anatomically-based facial rigs on characters.

JK: *I'd like to know more about your teaching. Do you turn your classrooms into a studio production environment?*

CL: Yes, I had a contingent of students from Seneca College in Toronto working on my last two films. In the case of *Ryan* we had four animators from Seneca working with us, and we had nine animators working with us on *The Spine*. These were students who had either already graduated or would soon graduate and were ready to be out on the job market—this was sort of like a thesis project for them.

The Psychology of CG

CG is a challenging medium, not readily known for organic looking, artistic self-expression, yet Landreth's *Ryan* takes a more "experimental" approach, unique in the world of studio-produced, photorealistic animation and visual effects. He uses 3D computer models, character animation, and rendering to create a risk-taking animated documentary about an animator and literally go "inside" Ryan Larkin, to reveal the sometimes painful story of Larkin's artistic career and struggles at the end of his life. It's not always intuitive to have an emotional response to CG character animation, yet Landreth succeeds in bringing the audience along with him into his observations and subtle admiration of his subject. Although most animated documentaries currently use a form of 2D or hand-drawn animation, Landreth continues to push the boundaries of the CG medium in *The Spine*, by using hi-tech software to explore very real and painful human relationships. The visual tension between the very palpable vulnerability of the married couple in *The Spine* and the sometimes hyperrealistic quality inherent in using CG digital technology reveals a quiet but powerful strength in Landreth's work and serves to identify him as one of the pioneers of this young art form.

The Iconoclastic Animator:
Paul Fierlinger

Biography

Paul Fierlinger was born March 15, 1936, in Ashiya, Japan, where his parents were Czechoslovakian career diplomats. He spent the years of World War II in the United States, and at the age of 12, while living in a boarding school in Podebrady, Czechoslovakia, Fierlinger created his first animated film by shooting drawings from his flipbook with a 16mm Bolex. In 1955 he graduated from the Bechyne School of Applied Arts. After two years of military service he did freelance work in Prague as a book illustrator and gag cartoonist for cultural periodicals under the pen name Fala.

Fierlinger established himself in 1958 as Czechoslovakia's first independent producer of animated films, providing 16mm films from his home studio for Prague TV and the 16mm division of

FIG 7.1 Paul Fierlinger.

Kratky Film. He created approximately 200 films, ranging from 10-second station breaks to 10-minute theatrical releases and TV children's shorts.

In 1967 Fierlinger escaped from Czechoslovakia and fled to Holland, where he pitched for a number of station breaks for Dutch television in Hilversum. He then went to Paris to work for a short stint as a spot animator for Radio Television France and ended up in Munich for six months, having been offered the job of key animator on a feature film at Linda Films (*The Conference of the Animals*). In Munich, prior to his departure to the United States, he married a Czechoslovakian compatriot and photographer, Helena Strakova.

Fierlinger arrived in the United States in 1968, and he initially worked for Universal Pictures as a documentary director (*Prague, The Summer of Tanks*). For a short period the Fierlingers moved to Burlington, Vermont to work for a local TV station; there, their first son, Philip, was born. In 1969 Fierlinger settled in Philadelphia where he was hired by Concept Films to animate political commercials for Senator Hubert Humphrey and other political candidates. In 1971 Peter, the Fierlingers' second son, was born.

Fierlinger formed AR&T Associates, Inc., his own animation house, in 1971, initially to produce animated segments for ABC's Harry Reasoner Specials and PBS's *Sesame Street*, including *Sesame Street's* popular *Teeny Little Super Guy* series, which runs to this day.

Since 1971, AR&T has produced over 700 films, several hundred of which are television commercials. Many of these films have received considerable recognition, including an Academy Award nomination for *It's so Nice to Have a Wolf Around the House*. Other awards include Cine Golden Eagles, and Best in Category Awards at festivals in New York, Chicago, Los Angeles, Annecy, Ottawa, Zagreb, Milan, Melbourne, Prague, London, and many other cities and countries—well over a hundred major film festival awards all together.

And Then I'll Stop . . . , a 1989 film about drug and alcohol abuse, has received more awards than any other of Fierlinger's films, including First Prize in Aspen, Colorado, and was selected for screening at MoMA's New Films, New Directors series and the London Royal Film Festival. At that time, the Fierlingers were divorced and their two young adult sons moved to San Francisco to pursue their own careers in computer and multimedia productions.

Fierlinger became a steady provider of many TV commercials and sales films for US HEALTHCARE, winning a variety of international awards. At this time he met and married Sandra Schuette, a fine arts painter (the Boston Museum of Art School and Philadelphia Academy of the Fine Arts.) Together they developed a small series of interstitials for Nickelodeon called *Amby & Dexter*, a *Sesame Street* series called *Alice Kadeezenberry,* and a 20-minute film of children's songs for The Children's Book of the Month Club, called *Playtime.*

In 1993 Fierlinger received a commission from PBS *American Playhouse* to create a one-hour autobiography, *Drawn from Memory*, which premiered at the 1995 Sundance Film Festival and has since been televised nationally and throughout the world. *Drawn from Memory* received several major film festival awards, including a presentation by invitation at INPUT 96 in Guadalajara, Mexico, and Best TV Feature Film at the International Festival of Animation in Annecy, France. A year later, ITVS, an agency of the Corporation for Public Broadcasting, commissioned Fierlinger to create a half-hour PBS special called *Still Life with Animated Dogs*. This film, about dogs and other creatures of a divine nature, premiered March 29, 2001.

In 1997, Fierlinger received a Pew Fellowship in the Arts award for the body of his work.

At the end of 1999, the production of *Still Life with Animated Dogs* had to be interrupted for several months so that the Fierlingers could develop and begin the production of an animation series for the Oxygen Network. Named *Drawn from Life*, the two-minute films featured the voices and simple stories of real-life women. This series won the Grand Prix of 2000 at the International Festival of Animation in Ottawa, Canada.

Still Life with Animated Dogs won the Golden Gate Award at the San Francisco International Film Festival and represented the United States at INPUT 2001 in Cape Town, South Africa. This film also went on to win First Prize at the International Festival of Animation in Zagreb 2002.

In April 2002, the Fierlingers received the prestigious Peabody Award for *Still Life with Animated Dogs*. Later that year their animation *Maggie Growls*, a biography of Maggie Kuhn, who established the Gray Panther advocacy group in the 1970s, was featured in the PBS/ITVS opening program of the weekly program *Independent Lens*.

In October 2003 the Fierlingers completed another ITVS/PBS special, *A Room Nearby*, which premiered in November at the Margaret Mead Festival in New York City and aired on PBS in March 2005. The film, which won the prestigious Grand Prix at the Animation Festival of World Cinema in Ottawa, Canada, as well as the 2005 Peabody Award, profiles five very different people who tell personal stories about their bouts with loneliness and how they benefited from the experience. Among the storytellers are people as diverse as the Harlem-born writer Lynn Blue and Hollywood film director Milos Forman.

In the fall of 2004 Fierlinger became a lecturer at the University of Pennsylvania's Fine Arts School, PennDesign, teaching an undergraduate and graduate course in 2D animation called Hand-Drawn 2D Computer Animation, and a freshman seminar, called In Pursuit of Originality, which is part of Penn's Benjamin Franklin Studies honor program.

FIG 7.2 Paul and Sandra Fierlinger.

The Fierlingers recently completed a feature-length film commissioned by Norman Twain Productions of New York. The 80-minute 16:9 ratio film, *My Dog Tulip*, is aimed for theatrical and HD/DVD home video and was released in late 2010; it's based on the book of the same title by British author J. R. Ackerley, and it stars Christopher Plummer and Lynne Redgrave. Paul is the director, scriptwriter, and sole animator of this production. The Fierlingers are currently working on their first film for eReaders and tablets, called *Slocum at Sea with Himself*, which will run approximately two hours and is based on the book *Sailing Alone Around the World*, by Joshua Slocum (1899).

The Fierlingers create their films in their home/studio using a hand-drawn, paperless 2D computer application, called TV Paint by TV Paint Developement in Metz, France, drawing and painting within this application via a Wacom tablet. They have been the principal beta-testers of this unique software since its initiation in 2001. Both Paul and Sandra are frequently invited to lecture and present their work at major universities and art institutions around the world.

Drawn from Memory

Some of the Fierlingers most celebrated works are among the most powerful examples of the documentary genre itself. Combining personal family history with his personal experience of World War II historical events, *Drawn from Memory* is Paul's animated autobiography of his difficult, yet eventful childhood. Created in 1993 before computers had viable animation programs, *Drawn from Memory* was animated on paper, photocopied onto special

FIG 7.3 Image from *Still Life with Animated Dogs*, a PBS/ITVS TV special, directed and animated by Paul and Sandra Fierlinger.
©*2001 Paul and Sandra Fierlinger.*

camera-ready sheets of acetate called *cels*, and then shot on the Fierlingers' 16/35mm Oxberry animation stand, using 16mm film stock. This work is a prime example of how an honest and well-told story of substance drives film; technology is not the most meaningful part in creating successful works of art.

Interview

Judith Kriger: *Can you talk a little about* Drawn from Memory? *What inspired you to make it?*

Paul Fierlinger: My own life. It's a story that turned even the worst listener into a good listener. Over and over again, people told me that I should write a book about my life. I don't write books but I do make films, and that's how I ended up making this film. We don't really like to show it anymore.

JK: *Why?*

PF: It's old. We can do much better work now.

JK: *In creating your work, who or what influences you?*

PF: Not much. <laughs> It's certainly not filmmakers, it's not animators. It's writers and illustrators or cartoonists. There's a strange thing about that word *cartoonist*. It implies juvenile thinking, and cartoons didn't start out to be that. I was influenced early in life by James Thurber, both his writing and his drawings, and Saul Steinberg was, I think, anybody's influence. The problem with Steinberg is if you start looking at him too much you start imitating him.

It's hard not imitating him. I try not to get too close to him in my work. Jules Feiffer also influenced me—the realism of his characters; the cartoon realism of his characters. Lots of writers. An awful lot of writers. I probably don't remember most of their names. I read many books, and I forget instantly the name of the author and the book.

My Dog Tulip

JK: *What attracted you to the story* My Dog Tulip?

PF: The dogs. <laughs> Sandra and I had a successful run with *Still Life with Animated Dogs*, and a pair of independent feature film producers from New York, Norman Twain and Howard Kaminsky, wanted us to select something to make our first theatrical feature.

FIG 7.4 Image from *My Dog Tulip*, a Norman Twain Production; distributed by New Yorker Films, directed and animated by Paul and Sandra Fierlinger.
©*2010 Paul and Sandra Fierlinger.*

They wanted us to base it on a well-known book, if possible. They wanted this project to be something that would be attractive to the masses. Independent producers are in a difficult predicament. They understand the role of independent films, but at the same time, they understand something more than filmmakers do, and that is how difficult it is to sell an independent film so that it makes enough money to make it worth the effort. Because of that, they have to think of things like basing the film on a famous book, using famous actors (for the narration), and all the things that some of us might consider unnecessary—or spoilers—but I understood that pretty early on. I understood it certainly in the first conversation, and I wanted to make *Slocum at Sea with Himself* [Paul and Sandra's current project for the eReader]. I wanted to make a sailing film, and they turned that down right away because they didn't know us. Slocum was the first man in history to sail solo around the world. Until then, nobody believed that it could be accomplished. It was a story at the end of the 19th century in America, which

is a fascinating period. But they didn't understand any of that. They kind of dismissed it right away; I didn't even get a chance to explain all of this, so I said "How about dogs?" And they grabbed that; they liked that. They could understand that that could make money. And then they said, "Do you have a book in mind?" I did have, actually. We had read *My Dog Tulip* several years before that and always knew that it would make a good animated film, in the back of our minds. I had actually already made some notes about that, in the book. So this was our opportunity to turn it into a film.

FIG 7.5 Image from *My Dog Tulip*, a Norman Twain Production; distributed by New Yorker Films, directed and animated by Paul and Sandra Fierlinger. ©2010 Paul and Sandra Fierlinger.

FIG 7.6 Image from *My Dog Tulip*, a Norman Twain Production; distributed by New Yorker Films, directed and animated by Paul and Sandra Fierlinger. ©2010 Paul and Sandra Fierlinger.

JK: *What is it about this story that appeals to you?*

PF: Ackerly [the writer of *My Dog Tulip*] was an iconoclast, and I like people like that. Here he was writing a story about his beloved dog, and after his dog died, Ackerly drunk himself to death within three years. He writes about this

dog in such unsentimental colors and understands the dog as an animal, not as a person.

JK: *You were attracted to the honesty of the story.*

PF: I've been described as someone who has always valued independence because I had domineering parents and grew up in a totalitarian country. Independence for me is a more important concept than is freedom, for instance. Though it's part of freedom, being independent is more significant to me. Ackerly was that sort of man, also.

FIG 7.7 Image from *My Dog Tulip*, a Norman Twain Production; distributed by New Yorker Films, directed and animated by Paul and Sandra Fierlinger. ©*2010 Paul and Sandra Fierlinger.*

FIG 7.8 Image from *My Dog Tulip*, a Norman Twain Production; distributed by New Yorker Films, directed and animated by Paul and Sandra Fierlinger. ©*2010 Paul and Sandra Fierlinger.*

FIG 7.9 Image from *My Dog Tulip*, a Norman Twain Production; distributed by New Yorker Films, directed and animated by Paul and Sandra Fierlinger. ©*2010 Paul and Sandra Fierlinger.*

FIG 7.10 Image from *My Dog Tulip*, a Norman Twain Production; distributed by New Yorker Films, directed and animated by Paul and Sandra Fierlinger. ©*2010 Paul and Sandra Fierlinger.*

FIG 7.11 Image from *My Dog Tulip*, a Norman Twain Production; distributed by New Yorker Films, directed and animated by Paul and Sandra Fierlinger. ©*2010 Paul and Sandra Fierlinger*.

FIG 7.12 Image from *My Dog Tulip*, a Norman Twain Production; distributed by New Yorker Films, directed and animated by Paul and Sandra Fierlinger. ©*2010 Paul and Sandra Fierlinger*.

JK: *Did your drawing style change for* Tulip?

PF: I draw dogs now much, much better. I cringe now when I look at the drawings I did for *Still Life with Animated Dogs*. When I was doing *Still Life*, I was aware of not doing a good job with the dogs; I wished I had time to work harder on it. When we decided to do *Tulip*, the first thing that flashed through my mind was that this project would make me learn how to draw dogs. I took that as a challenge, and certainly the dogs are drawn better in this film. I've become a better draftsman.

FIG 7.13 Image from *Still Life with Animated Dogs*, a PBS/ITVS TV Special; directed and animated by Paul and Sandra Fierlinger. *©2001 Paul and Sandra Fierlinger.*

FIG 7.14 Image from *Still Life with Animated Dogs*, a PBS/ITVS TV Special; directed and animated by Paul and Sandra Fierlinger. *©2001 Paul and Sandra Fierlinger.*

FIG 7.15 Image from *Still Life with Animated Dogs*, a PBS/ITVS TV Special; directed and animated by Paul and Sandra Fierlinger. *©2001 Paul and Sandra Fierlinger.*

FIG 7.16 Image from *Still Life with Animated Dogs*, a PBS/ITVS TV Special; directed and animated by Paul and Sandra Fierlinger. *©2001 Paul and Sandra Fierlinger.*

FIG 7.17 Image from *Still Life with Animated Dogs*, a PBS/ITVS TV Special; directed and animated by Paul and Sandra Fierlinger. *©2001 Paul and Sandra Fierlinger.*

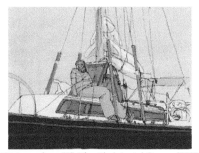

FIG 7.18 Image from *Still Life with Animated Dogs*, a PBS/ITVS TV Special; directed and animated by Paul and Sandra Fierlinger. *©2001 Paul and Sandra Fierlinger.*

FIG 7.19 Image from *Still Life with Animated Dogs*, a PBS/ITVS TV Special; directed and animated by Paul and Sandra Fierlinger. *©2001 Paul and Sandra Fierlinger.*

JK: *How could you tell that it would make a good animated film? How did you know that from reading the book?*

PF: Because it couldn't be done in any other way, in my opinion. That's why it had never been done. There's not enough of a story for it to be live action, and then there's the difficulty of having a trained dog. For a dog like Lassie, that costs a lot of money. You have to have several dogs—one Lassie isn't enough. For an independent filmmaker—or any filmma-ker—somehow the content of the book and the difficulty of shooting it live action just doesn't work out; the math doesn't work out for producers. But animated film—there are a lot of things that Ackerly says and thinks about that can only be successfully portrayed, in my opinion, with animation.

That's what we do in all our films. In any documentary, we don't tell just the story people are telling us, we look around their apartment or whatever, and we see all sorts of things, and we catch on to things that they don't think are part of their story, and I will use that in the background, in animation. So I can tell, if the story has to last two minutes, like our two-minute mini-documentaries, *Drawn from Life*, about ordinary women for the Oxygen Network, then I can say several things: I can portray what we edit out of our, let's say, one-hour conversation. I select two minutes of sound bites, and I'll illustrate, animate it. But also, there'll be lots and lots of material there that there isn't time to say, so I'll show it without words in the background.

FIG 7.20 Image from *My Dog Tulip*, a Norman Twain Production; distributed by New Yorker Films, directed and animated by Paul and Sandra Fierlinger.
©2010 Paul and Sandra Fierlinger

FIG 7.21 Image from *My Dog Tulip*, a Norman Twain Production; distributed by New Yorker Films, directed and animated by Paul and Sandra Fierlinger. ©*2010 Paul and Sandra Fierlinger.*

That always leads to a kind of abstract way of delivering the film—when you portray somebody's thoughts while at the same time, they are telling you a totally different story. You can't do that successfully, I don't think, with live action.

JK: *I think what you just described is what makes your films so powerful. You get to see a deeper story than the one that's presented at first glance.*

PF: And very often, after seeing the film, the interview subject will tell us, "Did I really say that?"

FIG 7.22 Image from *My Dog Tulip*, a Norman Twain Production; distributed by New Yorker Films, directed and animated by Paul and Sandra Fierlinger. ©*2010 Paul and Sandra Fierlinger.*

FIG 7.23 Image from *My Dog Tulip*, a Norman Twain Production; distributed by New Yorker Films, directed and animated by Paul and Sandra Fierlinger. ©*2010 Paul and Sandra Fierlinger.*

FIG 7.24 Image from *My Dog Tulip*, a Norman Twain Production; distributed by New Yorker Films, directed and animated by Paul and Sandra Fierlinger. ©*2010 Paul and Sandra Fierlinger.*

The Challenges of Film Distribution

As technological advances occur on a daily basis, distributing films becomes simultaneously easier and more challenging. Netflix, Vimeo, and YouTube simplify the process of viewing films, and worldwide self distribution has become simpler and more expedient than ever. Will future audiences want to pay money to go to the movie theater or prefer to stay home and watch streaming movies? In the Web 2.0 era, it's imperative for independent filmmakers to have a keen sense of understanding how consumers are viewing and engaging with the numerous forms of motion media content.

Interview

JK: *Does combining the Internet with TV present a problem for the independent filmmaker?*

PF: Everything we are doing now, we are doing for the eReader. We are not making *Slocum* for the theater anymore, because distribution is so difficult

and doesn't really pay that much. We've been interviewed a lot because of *My Dog Tulip*'s openings all over the country, and so we talk to an awful lot of journalists. At the end of many of these conversations when it drifts into small talk, many of them talk about their fears of losing their jobs—that their profession is coming to an end. They are very aware of that.

Newsprint is at its sunset. Newsprint is going to be on eReaders. It'll still be the printed word, but it's going to be on the eReader, and it will always have to be accompanied by images because of the nature of the eReader and the nature of humans today. They always want pictures with everything. So this type of illustration, of animation with realism—the way you were describing our work—is going to be very much in demand. All these writers might be writing short essays on some new invention or some new technology or something sociological, something about human behavior—some kind of human interest story—and they'll always need illustrations. Pretty soon, the illustrations will have to be, if possible, in motion; little "YouTubes" hanging in with the text. To say an awful lot in a very short amount of time—like seconds of motion—again, animation will work the best, if it's a realistic style of animation, the style that we do. I don't know what to call it still, because it's not realism; it's still cartoony. For lack of a better word, we call it *New Yorker*-style of cartooning, and people usually understand what that means. I know that kind of cartooning will be in demand. It's already in demand now; I have to turn down a lot of work, so there is a future for this style.

There's one problem though . . . It takes an awful lot of years to learn to animate that way. And it takes a strong will to learn it, to spend the time practicing it, and I don't see a lot of people doing that.

FIG 7.25 Image from *My Dog Tulip*, a Norman Twain Production; distributed by New Yorker Films, directed and animated by Paul and Sandra Fierlinger.
©2010 Paul and Sandra Fierlinger.

FIG 7.26 Image from *My Dog Tulip*, a Norman Twain Production; distributed by New Yorker Films, directed and animated by Paul and Sandra Fierlinger.
©2010 Paul and Sandra Fierlinger.

FIG 7.27 Image from *My Dog Tulip*, a Norman Twain Production; distributed by New Yorker Films, directed and animated by Paul and Sandra Fierlinger.
©2010 Paul and Sandra Fierlinger.

JK: *How did you first become involved with animation?*

PF: As a kid. I got interested when I was something like 8 years old. I really tried it for the first time when I was 12, and haven't stopped since. It has deep, psychological roots; it's steeped in a rotten childhood that I had. It was a rotten childhood in the midst of a certain kind of affluence and abundance. My parents were well-to-do diplomats, and they moved in affluent circles, but they placed my brother and me into foster homes. Those foster homes were headed by people like a university professor or a gentleman farmer,

people who were middle class. They didn't have the kind of affluence in the '40s as people do today, but for those years they were living well. Yet, as children we were impoverished. We grew up without love; nobody touched us from the cradle onward. So I have a difficulty with—I don't like people to hug me, especially total strangers, and I tell them that. For me, that's the most disgusting habit that has sunk into this nation. In the good old days of the '40s or '50s, people didn't "leap" at each other that way. <laughs> It does nothing for me. So I was very withdrawn. I was a difficult child; I gave the grownups a hard time. I was always calling for attention, and at the same time, when I got attention I was annoyed by it and I wanted to be left alone. I was a disturbed, unbalanced child, and the only time when I could find real serenity and peace of mind and a sense of balance was when I was drawing. And the grownups—it was as if they were turned off by a button; they would instantly leave me alone. Once they saw me drawing, it was almost like a spiritual occurrence. They would start talking in whispers, and they would say, "Look at his clever little hands." So it taught me from a very early age that drawing is a good escape place, and that's with me to this day. And of all the kinds of drawings you can do, if you want to draw for escape, animation is the best—because it goes on forever. <laughs> You have to spend a lot of time drawing.

JK: *I can well understand that!*

PF: Students don't understand this, because of their age.

FIG 7.28 Image from *My Dog Tulip*, a Norman Twain Production; distributed by New Yorker Films, directed and animated by Paul and Sandra Fierlinger.
©*2010 Paul and Sandra Fierlinger.*

FIG 7.29 Image from *My Dog Tulip*, a Norman Twain Production; distributed by New Yorker Films, directed and animated by Paul and Sandra Fierlinger. ©2010 Paul and Sandra Fierlinger.

The Art of Teaching Independent Animation

Interview

JK: *Can you describe your teaching philosophy? What are the main points you're trying to get across to your students?*

PF: In my syllabus, I thoroughly explain what the future is—namely, what I am doing now. I want to teach them what I know best, and this is how to make a living being an independent animator. My new direction that I see with absolute clarity now is producing animation for eReaders. I've been working successfully as an independent animator, and I want to prove it to them from my own example. To do that there is one thing they have to give up, and that is any thought of drawing cartoons of all the things they admire on television and on cartoon networks. Those kinds of cartoons won't sell, because the people who will buy it are grownups. And they will hopefully be intelligent, educated grownups, and they're not interested in your stuff, kiddies. You just have to give it up if you want to make a living.

JK: *If you want your work to be sustainable, you mean—not just what the current trend is.*

PF: Right. And that's a high hurdle for them. For instance, from the first day I'm teaching them very strictly that they have to use only stick figures. That's the only way to prevent them from drawing the ugly stuff that they like to draw: superheroes, robots, and aliens and all of that. I tell them that if they draw that, they'll get a low grade. I have to keep putting threats in their faces, and it still doesn't always do the job. It's incredible how tied they are to that—what I consider ugliness—and they don't seem to understand that it's not going to lead to anything. They're in a dead-end street by drawing that way.

JK: *I think a lot of people get into this medium and don't quite understand what it even is.*

PF: I make a point of asking students on the first day: First I talk about myself, where I come from, so I set an example, then I say that I want to hear from each one of you your brief biography and why you are here. I also explain to them why I am teaching.

FIG 7.30 Image from *My Dog Tulip*, a Norman Twain Production; distributed by New Yorker Films, directed and animated by Paul and Sandra Fierlinger. ©*2010 Paul and Sandra Fierlinger.*

FIG 7.31 Image from *My Dog Tulip*, a Norman Twain Production; distributed by New Yorker Films, directed and animated by Paul and Sandra Fierlinger. ©*2010 Paul and Sandra Fierlinger.*

JK: *Why are you teaching?*

PF: It's biological. It's a biological process. It's not for money, although right now after finishing the feature film [*My Dog Tulip*] and doing the next one with our own money, the money does come in handy, but that's not the motivation. The thing is, I've been working for half a century, and I've acquired a lot of experiences and a lot of knowledge. I heard once a radio show on human nature. Something caught my attention—somebody wanted to know, Why it is that only human beings live to such an old age? They live past the age, at first glance, of their usefulness. They've already reproduced, they've already done their hunting, they've put food on the table. Now, at first glance, the older they get, they are actually useless and have to

be taken care of, so you could say they are a burden to the tribe. The scientist on the show explained that yes, at first glance that is true, but there is a very clear biological reason for that, buried in our DNA, and that is that babies are born immature because they have such large brains. They come into the world physically unprepared, and they need a lot of attention—not just from their mothers, but from the whole clan. The whole clan should be helping out, because babies need so much attention. It takes a baby a long time to mature. Animals are mature within weeks or months and are ready to kill and eat. With humans, the older they get the more help they need, and it's the role of the elders, of the grandparents who up until then didn't have much use for the tribe's preservation of the species, now suddenly have a role in the preservation of the species: they teach. It's instinctively in all of us.

I myself hated school, and I did poorly in school. I had very little respect for my teachers. I'm not motivated by my past. But something in me, something came alive, and I have this urge, I have this instinct to teach what I know to others. And that's what brings me here. But when I ask my students why they want to be animators, most of them say because they like to watch animation. That's not a good reason. But that is their reason; they can't say anything else. That's why they want to draw what they've been watching all their lives; they have absolutely no motivation to be unique. That drives me nuts! I have to teach them how to pursue originality, and to them, at least at the beginning, that seems to be a foreign concept. They don't understand why it is so important to be original. It's bewildering that they don't have that ambition.

They have the wrong reasons to want to be animators: they want to be animators because they like watching it. Every kid likes to look at cars, and that would be like saying that every kid will grow up to be a car designer. My son always wanted to be a car designer, and I couldn't get it out of his head that that's a dead-end dream. Every year there are a dozen new cars in the whole world. Does he really believe that all by himself he's going to design a car and someone is going to buy it? That's the way he saw the world. And then as he got a little older, and he went to an industrial design school, and he began to understand—because he heard it from others, not just from his father—that if he's lucky he'll get a job in an industrial design firm, and if he's lucky maybe after five years he'll be allowed to design a door handle or a button on the dashboard and that there's nothing glamorous or nothing exciting about that. But he wanted to be a car designer just because he loved the shape of cars. So these students I get, they want to be animators because they love moving drawings, but they don't know the purpose of it. They don't think about whether or not they have anything to say with their animation.

JK: *Yes, I see that a lot.*

PF: I want to teach them how to be successful by having a lot to say.

JK: *How do you teach them that? Isn't that life experience? How do you teach a person in their 20s what to say?*

PF: That's the objection that most of them pose when they begin to understand what I'm saying. And they say, "For you it's easy, because you've lived a long life and you have a lot of experiences and many interests; you can't expect that of us. We're only 22 years old." And I say, "But there are things you're very good at, and no one is better at this than you, and that is: You know what it's like to be a 22-year-old. I don't know that any more. Though I was once a 22-year-old, I have no idea what kinds of stress or trauma or problems you go through. I'm sure you all have lots of stresses. If you make a decent little film about what it's like to be a 22-year-old, you're going to have lots of people interested in it. Not just other 22-year-olds, but parents and teachers of 22-year-olds. And that begins to awaken them. So I'm telling them their first assignment is to make a little video essay on the theme, "My home is where I hang my hat." In other words, a little documentary about where you live. Then I show them the film *Iowa Bird Story* by Alex Soth. It's a combination of live-action, some plain text, some photography, some videography, talking, and some music. It's about five minutes long. The editing is astonishing because it breaks all the rules. Your first instinct is to think that it's completely unedited; it looks as if there's no editing here. This little film has been my recent greatest influence because of what it taught me: Here is a film designed for an audience of one, one person at a time. It's going to be watched on the pages of *The New York Times* online; usually by one person. You don't have two or three people reading *The New York Times* on one computer monitor. So it's watched by one person. That's a totally different kind of audience, so you have a very intimate connection with this anonymous person. You're talking one to one. Sandra and I are making *Slocum*, about a sailor at the turn of the century, but we're saying it only to a single person in a very intimate setting. We therefore have to tell that story differently. That's what my students have to understand in their first lesson. I want them to show their creativity.

FIG 7.32 Image from *My Dog Tulip*, a Norman Twain Production; distributed by New Yorker Films, directed and animated by Paul and Sandra Fierlinger. ©2010 Paul and Sandra Fierlinger.

FIG 7.33 Image from *My Dog Tulip*, a Norman Twain Production; distributed by New Yorker Films, directed and animated by Paul and Sandra Fierlinger. ©*2010 Paul and Sandra Fierlinger.*

JK: *Do you have any favorite documentaries? Do you show documentaries to your students?*

PF: Yes, I love documentary films! I like to show the film *The True Meaning of Pictures* to my students. We picked it up at a documentary festival; Sandra and I are invited to a lot of documentary festivals. It's about a photographer who takes pictures of "rednecks" living in Appalachia. The photographer was born there and grew up there and is friends with some of the people who appear in the doc. Clearly, the photographer knew them because he had their trust. He made a book of photographs of these people. They're very well-made, impressive photographs. By looking at these pictures, you can see that they trust him, he shows their worst qualities. Then, a couple made the film about the photographer taking those pictures, and what they revealed is that everything was staged. All the pictures were staged! It's a wonderful topic for discussion with students. It's a trigger film that starts a discussion to help "define" what documentary is. Is what the photographer is doing honest?

To me, the best documentary ever made is *The Three Rooms of Melancholia*. I was giving a master class about making animated documentaries at the Amsterdam Festival of Documentary Films, and they gave me this film as a gift. It happened to have been made by a Finnish director I knew in Philadelphia, Pirjo Honkasalo. She's a "star" filmmaker in Finland; she's made a few very bleak and wonderful feature films. This is a feature, wide-angle documentary film [meaning it's shot with a large camera], about children who are victims of the war in Chechnya. It's shot from the Russian side and from the Chechen side. There's no narration, it doesn't have to be translated; it's universal in all languages. There isn't even that much dialogue, yet you "get" the whole story. It's amazing!

JK: *It's the best documentary you've ever seen because it's universal, or . . . ?*

PF: Because it's excellent craftsmanship; it's excellent filmmaking. It was made under very difficult conditions, and how she managed to do it with

a crew . . . It starts off on the Russian side, in a school for 11-year-old boys who are military cadets. Many of the boys are from Chechnya; they're there for reeducation. At the beginning, everyone thinks that these are actors. Then I heard later on—it disappointed me a little, but not too much—that in a way, it was set up. She did tell them where to stand and to look "sad," or whatever. In other words, she directed them. But that's the only part in that school that was directed. Otherwise, it's real. It's a real school, real children, and then it goes to where they came from, how they got there. It's in three parts, that's why it's called *Three Rooms of Melancholia*. It's there, it's in Chechnya, and somewhere in-between, how they escape from there. They were in hiding in another part of Russia, across the border. It's a striking film. You can't forget it; it stays in your mind for weeks. It's the best antiwar documentary I've ever seen, and there's no fighting in it, it's all after the fighting. There's not one gunshot in the entire film.

FIG 7.34 Image from *My Dog Tulip*, a Norman Twain Production; distributed by New Yorker Films, directed and animated by Paul and Sandra Fierlinger. ©2010 Paul and Sandra Fierlinger.

JK: *What do you think are some of the deficiencies in documentary filmmaking?*

PF: Well, that's a good segue to the DocAviv Festival in Tel-Aviv, because I was recently a judge of student films there. All of the films were Israeli-made films, and I have to say, I've never seen such high quality of films at any student festival. And they don't even realize it about themselves! They were pleased and surprised to hear this. There were three jurists; two Israelis—much younger than I—one man, one woman, and they were both freelance documentarians, and they both taught in documentary schools.

I was elected the foreman of the jury—because of my age, or something—and I said, "Let's do it this way. We'll write down on a piece of paper what we think is the absolute shoo-in, plus two other films that could be a substitute for our first choice." We were only giving one award, just a first

prize. The first film Sandra and I watched was so fantastic that I said, "This has to be the winner; there can't be anything done better than this film at a student festival." After that, I saw another one that surpassed this one, by far, and that's the one I wrote down. What the two other judges wrote down was not the same. They chose a film I didn't consider at all, because I thought it was very poorly shot and I thought it had a lot of faults. It was about a rescue dog kennel in Israel that was in a decrepit spot close to the security fence. The people who worked there were creepy, tattooed guys who would come and go. The only person who really loved the dogs, who had a dog of his own, was an Arab guy who ran the kennel. This was surprising, because Arab cultures dislike dogs; they consider them to be filthy. During the course of the film various items started disappearing from the kennel. The guy who ran the kennel started organizing how to figure out who the thief was . . . but it turned out that he was the thief. During the course of the story, we learn that he's very poor, he has eight children, and he has a hard time supporting his family. We also learn that he loves his work and he loves the dogs. At the end of the film it's decided not to fire him, but he is reprimanded.

I didn't like the story, I didn't like the way he got away with it. The two other jurors attacked me. And then I let them have it, because I said, "It's two of you against me. These are all Israeli films, you are teachers in schools, and you know the politics much better than I do, so I'll give up and let you decide it."

The next day, Sandra and I were invited to an animation school in the north, and I saw a picture of the movie that I liked, called *Memoir*.

FIG 7.35 Image from *My Dog Tulip*, a Norman Twain Production; distributed by New Yorker Films directed and animated by Paul and Sandra Fierlinger. ©2010 Paul and Sandra Fierlinger.

JK: *Why was that your favorite film?*

PF: I liked it because it was introspective. The filmmaker documented his own anguish over the death of his best friend in war. He drew you into his family,

and he made a documentary film about his best friend. He studied himself, he was trying to figure out why he couldn't get the loss out of his own head, he went into great emotional depth. For a student to do this . . .

I brought this up to the other jurors when they asked why I liked this film, and they said, "You don't realize that our students are pretty old compared to yours." After high school, they first go into the military, both girls and boys. After that they travel, they see the world, and then they go to college, which is great. That's the way to do it. I would love to have students with that kind of a background; they've grown up a little. You can't think of them as kids; they're young adults and they've seen something of life. Whether or not they've actually been in a war, they've certainly come very close to it. They serve in an army that's in a war zone and that has to do a lot to you, and then they go around the world visiting different countries. They come prepared to go to college.

The professors who were showing us around told us—no one could under-stand why *Memoir* didn't win—they explained to me, "Well, that woman is an Arab, an Israeli Arab." All our discussions suddenly came back to me, and I realized what it had been about: political correctness. This disappointed me terribly, and if I had known that, I would have put up more of a fight.

The morality of the winning film was very blurred, and there was no way the thief should have gotten off so lightly. I would have at least liked to have seen some kind of remorse, and he was devious about how he was hiding his thievery. Their response was, "But he's an Arab, and he's extremely poor."

JK: *So you're saying a deficiency in documentary filmmaking is political correctness?*

PF: Yes, and don't we all see it a lot?

JK: *Sure, and not only in documentary.*

PF: We are proud of ourselves as being a free country, yet there is fear among peers that if you say something . . . it happens all the time on television. Remember the O.J. Simpson trial?

JK: *As a documentary filmmaker, how can you prevent yourself from investing your personal views into your films? They're always slanted, aren't they?*

PF: Yes, I don't believe that any story can be told with objectivity. The act of selecting scenes and the way in which they're put together *is* putting in a point-of-view. You can't make a purely objective film, and if you could, it wouldn't work. Politicians try to be that way, and you can see that they're insincere, that they're lying. It wouldn't be interesting if you didn't show your point-of-view.

JK: *Could you not then say the same thing about the winning film?*

PF: It didn't bother me so much about the film; what bothered me was why the two jurors were defending it. The female juror clearly wanted it to be first,

and she had political reasons for that. It was important for her to show that her people can love dogs, that not all Arabs hate dogs, and it helps her cause. The film was made by Israeli-Arab students, so it had that slant to it—fine. But it was not a fair judgment of the film. People in the festival were shocked that it won, and it put a terrible light on me, of course, too. How could the three of us pick that film?

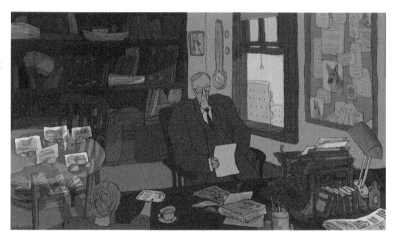

FIG 7.36 Image from *My Dog Tulip*, a Norman Twain Production; distributed by New Yorker Films, directed and animated by Paul and Sandra Fierlinger. ©*2010 Paul and Sandra Fierlinger.*

The Message Is the Medium

As a filmmaker, it is very important that the style suit the story. The techniques used should not in any way interfere with or work against the texture of the subject matter. An animator has to design everything from scratch, whether hand-drawn, stop-motion puppets, CG, or a mixed-media approach combining different kinds of frame-by-frame genres. How does the director of animated docs approach the look development of the film when there are so many styles from which to choose?

Interview

JK: *To me, your films are very intimate and honest. You use an uncomplicated line quality to tell complex and deep human stories. Do you think it's possible to create such intimacy with CG?*

PF: No, I don't believe so. Not yet. I used to say that it would never happen, and I gave all the reasons why I thought this way—namely, the technology was very limited. I used to say that it was because everybody uses the same skeleton and puts on the same skin, and all their figures either look like ants, or robots, or rubber toys. They're all made the same way. Your "hand-writing" doesn't show up in this kind of animation. However, I'm beginning to

change my mind about that due to seeing the Japanese Tiger Woods reenactments. They came out about a week after the Tiger Woods story broke—they showed us how it happened within days of it being on the news. It taught me that it is possible to get emotion with CG characters.

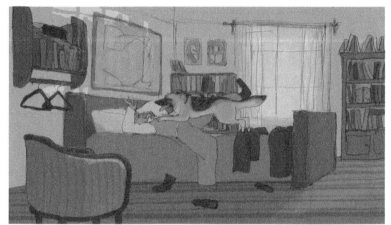

FIG 7.37 Image from *My Dog Tulip*, a Norman Twain Production; distributed by New Yorker Films, directed and animated by Paul and Sandra Fierlinger. ©*2010 Paul and Sandra Fierlinger*.

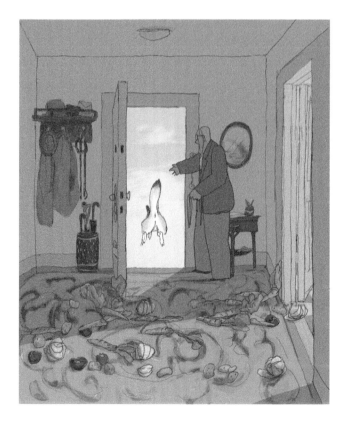

FIG 7.38 Image from *My Dog Tulip*, a Norman Twain Production; distributed by New Yorker Films, directed and animated by Paul and Sandra Fierlinger. ©*2010 Paul and Sandra Fierlinger*.

JK: *I love CG and have worked in it for many years, yet there is something so fascinating about the hand-drawn line. As you've said, it is like a person's signature.*

PF: There are people who can analyze handwriting and give a pretty good description of who you are. I had a teacher in art school who claimed that he could describe people by looking at the pencils they had whittled. That's how we sharpened our pencils; we had to use pen knives. Anything you do by hand defines you; it shows your personality.

JK: *I don't think there would be a purpose to your making your films in CG.*

PF: No. People wouldn't want to watch them. A lot of the people who are coming to *Tulip*, for instance, want to see hand-drawn computer animation. They are curious about it. They see that the lines shake and that it has qualities that today's animation does not have. Reviewers use the words "crude" and "primitive" when describing our work, and they can't understand why they like it when the line quality is so shaky and imperfect.

JK: *And that's the charm of it; it's imperfect and original. How would you describe your work? Are they animated documentaries?*

PF: Yes. Everything Sandra and I do now is animated documentaries.

FIG 7.39 Image from *My Dog Tulip*, a Norman Twain Production; distributed by New Yorker Films, directed and animated by Paul and Sandra Fierlinger. ©2010 Paul and Sandra Fierlinger.

JK: *Why not just create your stories in live action? Why is it necessary for them to be animated?*

PF: There are lots of things you aren't able to do with live action. Documentary films are mostly about the past, and you can't re-create the past as convincingly in live action as you can with animation. Reenactments are terribly expensive and don't work well; they look "hokey." But in animation, it's just the opposite—they're attractive and interesting, if they're done the right way. Another aspect is that you can go into the imagination of people. If a talking head is telling you a story and you don't have enough footage, and they're not only talking about the past but they are talking about their ideas, you can't illustrate this as well in any other medium. Animation is made of shortcuts; everything can be told at a rate that is ten times the speed of live action, and you can condense things and use metaphors without being hokey. If you're trying to use metaphors in live action using visual effects, it's going to come out looking cheesy. Animation can salvage the job of many, many documentaries.

JK: *That's the trend right now, isn't it? It seems many documentaries use a minute or so of animation, and often that's the most interesting part of the film.*

PF: Yes, and they're aware of that, so they want to include animation. Why not then go to the next step and make the entire documentary animated?

FIG 7.40 Image from *My Dog Tulip*, a Norman Twain Production; distributed by New Yorker Films, directed and animated by Paul and Sandra Fierlinger.
©2010 Paul and Sandra Fierlinger.

There's No Business Like the eReader Business

Joshua Slocum was the first person to sail around the world alone, and he wrote about his adventures at sea in his 1899 memoir, *Sailing Alone Around the World*. The Fierlingers' animated adaptation of Slocum's story is scheduled for self-published serialized eReader installments in 2012.

FIG 7.41 Still from *Slocum at Sea with Himself*; distributed, directed, and animated by Paul and Sandra Fierlinger. *©2011 Paul and Sandra Fierlinger.*

FIG 7.42 Still from *Slocum at Sea with Himself*; distributed, directed, and animated by Paul and Sandra Fierlinger. *©2011 Paul and Sandra Fierlinger.*

JK: *Can you describe what you're currently working on? What is a typical workday like?*

PF: I'm doing something new to me now, and it's working very well. I've shown it to people of all ages, and I get the same reactions from both students and older people—it's really remarkable in that way: I'm working on an animated graphic novel for the Internet. I'm using word balloons and things like that instead of spoken language, so there goes the role of the actor. You don't have to find someone with just the right voice, and you make the viewer read while they're watching. I'll freeze a picture and cover half the frame with text that you have to read, so that it looks like an illustration in a book. I'm also using text without any picture at all, just like in silent movies—white letters on a black field. It's remarkable how people still like to read; they're so curious to see what's written, because that's where the information is coming from. Even if there are moving images and action, people will read the text first. I don't hold on the text for too long; that makes them want to see it again. Because they know they'll be able to play it again on their eReader or iPad, they don't feel pressured or rushed to finish it fast. Any kind of device that combines the printed word with film is attractive to the eReader. You have to remember one thing: you are now telling a story to an audience of one, just as with a book. You can do the same things you can do with a book: you can stop it to "reread" the paragraph, or go back a few pages if you want.

FIG 7.43 Still from *Slocum at Sea with Himself*; distributed, directed, and animated by Paul and Sandra Fierlinger. ©2011 Paul and Sandra Fierlinger.

FIG 7.44 Still from *Slocum at Sea with Himself*; distributed, directed, and animated by Paul and Sandra Fierlinger. ©*2011 Paul and Sandra Fierlinger.*

FIG 7.45 Still from *Slocum at Sea with Himself*; distributed, directed, and animated by Paul and Sandra Fierlinger. ©*2011 Paul and Sandra Fierlinger.*

JK: *Is this a story you're adapting?*

PF: Yes, I'm adapting a story called *Slocum at Sea with Himself* that was written about 150 years ago by a sailor about his voyage around the world. It's a documentary in the sense that it's a true story, and I'm using the words of the person who lived the story and wrote about it, and I'm going to publish it in little five-minute installments—just like in the 19th century. <laughs> The viewer will have something to look at on their iPad or their iPhone or their laptop while they're bored in school or in their offices or on the subway. They can look at it again and again on their eReader and find new things in there. A new installment will be available every Friday and be sold for a very low price. There's a new, wide world opening for animators, because people

FIG 7.46 Still from *Slocum at Sea with Himself*; distributed, directed, and animated by Paul and Sandra Fierlinger. ©2011 Paul and Sandra Fierlinger.

love to watch animation—serious animation—which you can see from the very first drawing.

JK: *In a way it's similar to the popularity of the political cartoon; that appeal has never gone away.*

PF: Yes. The way I approach this is to think about the reader first. I keep in mind that it's a single person who will be looking at my work; it's not to an audience anymore. When producing work for a television audience, for example, you have to somehow guess the group's dynamics. That audience could be made up of a gathering of kids or an entire family or people sitting in a bar or at the airport. With the eReaders, it would be rare that two people

FIG 7.47 Still from *Slocum at Sea with Himself*; distributed, directed, and animated by Paul and Sandra Fierlinger. ©*2011 Paul and Sandra Fierlinger.*

FIG 7.48 Still from *Slocum at Sea with Himself*; distributed, directed, and animated by Paul and Sandra Fierlinger. ©*2011 Paul and Sandra Fierlinger.*

FIG 7.49 Still from *Slocum at Sea with Himself*; distributed, directed, and animated by Paul and Sandra Fierlinger. ©*2011 Paul and Sandra Fierlinger.*

would be looking at them at the same time, in the same way that you don't see two people reading the same book at the same time. This kind of audience is altogether different; much more forgiving and easier to please.

JK: *What is a typical workday like for you?*

PF: When I tell the people who've interviewed me that I work anywhere between 12 and 16 hours a day, nobody quotes me! They all say that I work 12 hours a day; nobody wants to believe that I could possibly work 16 hours a day.

JK: *I think those of us who work in animation production would certainly believe you!*

FIG 7.50 Still from *Slocum at Sea with Himself*; distributed, directed, and animated by Paul and Sandra Fierlinger. ©2011 Paul and Sandra Fierlinger.

FIG 7.51 Still from *Slocum at Sea with Himself*; distributed, directed, and animated by Paul and Sandra Fierlinger. ©2011 Paul and Sandra Fierlinger.

PF: Three hours of teaching totally exhausts me, both mentally and physi-cally. Yet 16-hour stretches of animating never exhaust me; there's nothing to it for me. So, I work about two "shifts" per day.

JK: *How much finished animation do you produce per day? Do you measure it in feet or seconds?*

PF: On *Tulip*, my producer was keeping track of us. He said we made 45 seconds a week. Usually, we finish about one minute per week. *Tulip* was more difficult in many ways. Drawing dogs, for instance. It's slower, and there's a dog in almost every frame, and sometimes there were six dogs in a scene together. A minute a week means working two shifts, seven days per week—never taking a weekend off or a vacation. It took us two and a half years to draw and paint *Tulip*. People who aren't involved in animation think,

FIG 7.52 Still from *Slocum at Sea with Himself*; distributed, directed, and animated by Paul and Sandra Fierlinger. ©*2011 Paul and Sandra Fierlinger.*

FIG 7.53 Still from *Slocum at Sea with Himself*; distributed, directed, and animated by Paul and Sandra Fierlinger. ©*2011 Paul and Sandra Fierlinger.*

FIG 7.54 Still from *Slocum at Sea with Himself*; distributed, directed, and animated by Paul and Sandra Fierlinger. ©2011 Paul and Sandra Fierlinger.

FIG 7.55 Still from *Slocum at Sea with Himself*; distributed, directed, and animated by Paul and Sandra Fierlinger. ©2011 Paul and Sandra Fierlinger.

FIG 7.56 Still from *Slocum at Sea with Himself*; distributed, directed, and animated by Paul and Sandra Fierlinger. ©2011 Paul and Sandra Fierlinger.

FIG 7.57 Still from *Slocum at Sea with Himself*; distributed, directed, and animated by Paul and Sandra Fierlinger. ©*2011 Paul and Sandra Fierlinger.*

FIG 7.58 Still from *Slocum at Sea with Himself*; distributed, directed, and animated by Paul and Sandra Fierlinger. ©*2011 Paul and Sandra Fierlinger.*

FIG 7.59 Still from *Slocum at Sea with Himself*; distributed, directed, and animated by Paul and Sandra Fierlinger. ©*2011 Paul and Sandra Fierlinger.*

FIG 7.60 Still from *Slocum at Sea with Himself*; distributed, directed, and animated by Paul and Sandra Fierlinger. ©2011 Paul and Sandra Fierlinger.

"Wow! That took a long time!" But it's really extremely fast to do it in two and a half years.

Drawn from a Lifetime of Experience

Fierlinger's storied career includes his embrace of new technologies and his rethinking of how he can best reach his audience. In his earlier works, Fierlinger painfully recalls how as a child he was not fluent in Czech and how hard it was for him to fit in, yet over the years he has naturally developed an eloquent language of his own, albeit in animated form. His articulate films champion the universal right to criticize established, traditional values, which is part of what make his films so dynamic and enjoyable. Fierlinger is truly dedicated to using animation to tell personal, human stories with a sense of exploring the spiritual. He adds his honest visual commentary in the same way that a political cartoonist is easily able to summarize a complex event with a few simple lines and shades of color. With half a century of experience behind him, Fierlinger's extensive library of masterfully made animated documentaries challenges the viewer to understand and accept his foibles, and his audiences are all the richer for it.

Index

Note: Page numbers followed by f indicate figures

Printed and bound by CPI Group (UK) Ltd, Croydon, CR0 4YY

23/10/2024

01778231-0002